The Forest: Politics, Poetics, and Practice

The Forest: Politics, Poetics, and Practice

The Forest: Politics, Poetics, and Practice

KATHLEEN GONCHAROV

NASHER MUSEUM OF ART
AT DUKE UNIVERSITY

Published for the opening of the
Nasher Museum of Art at Duke University,
The Forest: Politics, Poetics, and Practice,
October 2, 2005–January 13, 2006.

Nasher Museum of Art at Duke University
2001 Campus Drive, Durham, NC 27705
(919) 684-5135
www.nasher.duke.edu

The Forest: Politics, Poetics, and Practice is co-sponsored
by Duke University's Nicholas School of the Environment
and Earth Sciences.

Cataloging-in-Publication data are
available from the Library of Congress.
Library of Congress Control Number: 2005928432
ISBN: 0-938989-25-1
Distributed by Duke University Press

Text by Kathleen Goncharov
 Adjunct Curator of Contemporary Art
 Nasher Museum of Art at Duke University
Edited by Guy Lesser
Design by Florio Design, LLC, New York
Printed by Letter Perfect, Inc., Charlotte, North Carolina

If, despite our efforts, we have not correctly identified
all copyrights here, holders are asked to contact the
Nasher Museum of Art at Duke University.

Cover illustration:
PHYLLIS GALEMBO
Little Red Riding Hood and Brown Bear, 1999
Cibachrome print
30 x 40 in.
Courtesy of the artist and
Sepia International, New York, NY
Photo © Phylllis Galembo
Cat. 20

Back cover illustration:
AN-MY LÊ
Ambush #2 (Small Wars), 1999–2002
Silver gelatin print
30 x 40 in.
Courtesy of the artist and
Murray Guy, New York, NY
Lent by Robert Hobbs and Jean Crutchfield,
Richmond, VA
Photo © An-My Lê
Cat. 8

CONTENTS

We are pleased to present *The Forest: Politics, Poetics, and Practice* as the Nasher Museum's inaugural exhibition of contemporary art. *The Forest* includes works by thirty international artists who address some of the most pressing environmental and ecological issues of our day in a range of compelling ways. Many of the artists in the exhibition are also concerned with literary and historical notions of the forest, and how those ideas affect us in today's world. In terms of both its artistic quality and engagement with ideas, this exhibition sets a standard we aim to maintain in our contemporary art program, and indeed in all our future exhibitions. The show features great work by important artists, presents new knowledge across a range of disciplines, and engages its viewers in a significant visual and intellectual dialogue. For all this we are extremely grateful to Kathleen Goncharov, our adjunct curator of contemporary art, who conceived the idea for the exhibition and carried it out in such a compelling way.

This project could not have been realized without the support of many dedicated and talented people. First and foremost we would like to express our appreciation to the artists. Each of them brings a unique vision to the important and diverse range of issues raised in the exhibition. We are delighted that we were able to commission Wolfgang Staehle and Patrick Dougherty to create new work especially for the exhibition.

We are grateful to the lenders whose tremendous generosity was essential in securing key works. They include William and Ruth True and Eric Fredericksen, director of Western Bridge in Seattle; the Rubell family and director Mark Coetzee in Miami; Martin Z. Margulies and his curator Katherine Hinds, also in Miami; Heather and Anthony Podesta in Falls Church, Virginia, and their curator Gaby Mizes; Robert Hobbs and Jean Crutchfield in Richmond, Virginia; Suzanne and Howard Feldman in New York; Boris Hirmas Said in Coronado, California; and the Joslyn Art Museum in Omaha, Nebraska. We would also like to thank Professor Wu Hung of the University of Chicago, leading authority in the field of Chinese contemporary art, for his assistance in securing the participation of Yang Fudong. The New Museum of Contemporary Art in New York generously allowed us to screen works from their production, *Point of View: An Anthology of the Moving Image*, and the Fondation Cartier pour l'Art Contemporain granted us the privilege of presenting a commissioned work by Stephen Vitiello from the exhibition *Yanomami: Spirit of the Forest*.

We thank the following galleries for their assistance in dealing with the exhibition's complicated logistics: 303 Gallery, Alexander and Bonin, James Cohan Gallery, Ronald Feldman Fine Arts, Galerie Lelong, Barbara Gladstone Gallery, Marian Goodman Gallery, Casey Kaplan, Yvon Lambert New York, Luhring Augustine Gallery, Robert Miller Gallery, Murray Guy, PaceWildenstein, Postmasters, The Project, Max Protetch Gallery, Paul Rodgers/9W, Jack Shainman Gallery, ShanghArt, and Donald Young Gallery.

We are also grateful to the Mary Duke Biddle Foundation, whose financial support sustains many aspects of the museum's artistic and educational programs, and the Nancy Hanks Endowment at Duke University for funding the catalogue. We also thank the generous donors who made the Patrick Dougherty commission possible, including our Friends Board President Mindy Solie, who led the initiative. Donors include Mr. and Mrs. Jeffrey Barber, Mr. and Mrs. Robert Bell, Mr. and Mrs. James Boyd, Mr. and Mrs. James Brame, Mr. and Mrs. Dennis Dougherty, Mr. and Mrs. Stuart Frantz, Mr. and Mrs. John Funkhouser, Mr. and Mrs. John Glushik, GlaxoSmithKline, Mr. and Mrs. Ted Griffin, Dean Hamric, Dr. and Mrs. Richard Hawkins, Mr. and Mrs. Chris Hegele, Mr. and Mrs. Garheng Kong, Ellen Medearis, Linda McGill, Mr. and Mrs. Mitch Mumma, Drs. John and Peggy Murray, Dr. and Mrs. David Paulson, David Pierson, Mr. and Mrs. Larry Robbins, Joe Rowand, Mr. and Mrs. Guy Solie, Mr. and Mrs. Stevan Stark, SunTrust, and Dr. and Mrs. Samuel Wells.

The staff of the Nasher Museum of Art at Duke University has worked tirelessly to make this exhibition possible. Sarah Schroth, former interim director and now the Nancy Hanks Senior Curator, has been a guiding light and enthusiastic supporter of the exhibition from the beginning. Registrar Jeffrey Bell and his assistant Myra Scott expertly handled the complicated process of administering loans and shipping art works. Brad Johnson, the museum's talented preparator, made certain the works were handsomely presented and that the technology was in place and working properly. Nasher associate curator Anne Schroder was very helpful with research; communications manager Wendy Hower Livingston dealt efficiently with catalogue details and ensured that a wide and diverse audience saw the exhibition, and curator

of education Juline Chevalier created a range of programs for the show. Staff members Martha Baker, Rita Barden, Michelle Brassard, Dorothy Clark, Carolina Cordova, Harvey Craig, Kelly Dail, Alan Dippy, Ken Dodson, and Eula Pence also significantly contributed to the process of organizing and presenting the exhibition. We are also grateful to the docents and Friends of the Nasher Museum of Art.

We were delighted to collaborate on this project with Duke's Nicholas School of the Environment and Earth Sciences and would particularly like to thank its dean, William H. Schlesinger, for taking time from his demanding schedule to advise and guide us on the educational component of the exhibition. We owe a special debt of gratitude to Judson Edeburn, Duke Forest Resource Manager, for his time and expertise in making the commissions by Wolfgang Staehle and Patrick Dougherty possible, and Ronnie Lillie and the Audubon Tree Service for providing a tree from the forest to complete Paloma Varga Weisz's installation. We also thank Paul Manning, J. Randal Kolls, and Don Ball of the Washington Duke Inn & Golf Club. We are grateful to Rob Sikorski and Pamela Gutlon of Duke's John Hope Franklin Center for Interdisciplinary and International Studies for organizing a concurrent related exhibition of work by Sarah Ann Johnson. Finally, we express our thanks to Kathleen Goncharov, who conceived the idea for this wonderful show, and whose artistic and intellectual vision shaped it.

Kimerly Rorschach
Mary D.B.T. and James H. Semans Director

ADDITIONAL ACKNOWLEDGMENTS

Nicholas School faculty member Daniel D. Richter was especially helpful with advice and information about forestry in general as well as its relevance to Duke University, as was Steve Anderson, president of the University's Forest History Society and its archivist Cheryl Oakes. Duke professor Rob Jackson's excellent book *The Earth Remains Forever* was very informative about issues of global warming and current ecological thinking as was William Ross Jr., secretary of the North Carolina Department of Environmental and Natural Resources, about forest policy in the state. Duke's art and architecture librarian Lee Sorenson was of great help with research, and the University's art history professors Kristine Stiles and Richard Powell and art faculty member Peter Lasch were enthusiastic supporters of the exhibition as were Duke alumni and friends Blake Byrne, Susan Inglett, Gerrit Lansing, Jason Rubell, Bill True, and Rick Segal.

I am grateful to the following people for their assistance: Claudia Altman-Siegel, Douglas Baxter, Mark Baron, Elise Boisante, Ted Bonin, Josie Browne, Chana Budgazad, Alexis Cantor, Ron and Frayda Feldman, Jeanne Freilach, Elise Goldberg, Simon Greenberg, Janice Guy, David Harper, Christian Haye, Lorenz Helbling, Royce Howes, Mark Hughes, Ted James, Casey Kaplan, Peggy Kaplan, Luisa Lagos, James Lavender, Charlie Manzo, Wade Miller, Margaret Murray, Marco Nocella, Sarah Paulson, Courtney Plummer, Simon Preston, Max Protetch, Paul Rodgers, Mary Sabbatino, Julie Saul, Magda Sawon, Barbara Schwann, Jack Shainman, Lisa Spellman, Mari Spirito, and Sandra Antelo-Suarez.

I would also like to thank Blake Goble and Robert Ransick for their help with the design of the show. Charles Doria's expertise in the classics and literature was invaluable in formulating the catalogue essay, and Valerie Smith made excellent suggestions regarding artists for the exhibition. The very talented catalogue designer Linda Florio and editor Guy Lesser also deserve accolades for their contributions to the project. Finally I would like to thank Kimerly Rorschach and Sarah Schroth for giving me the honor of organizing the Nasher's first exhibition of contemporary art. If I have inadvertently forgotten anyone, I offer my sincerest apologies and regrets.

Kathleen Goncharov
Adjunct Curator of Contemporary Art

The Forest: Politics, Poetics, and Practice

IN 2004, WANGARI MAATHAI became the first environmentalist to win the prestigious and much coveted Nobel Peace Prize. The biologist founded the Green Belt Movement, an influential and innovative non-government organization based in Kenya, nearly thirty years ago. One of the organization's most ingenious early programs involved paying poor women to plant tree seedlings. To date, over 30 million new trees have taken root in her native country. The program serves the common good by promoting reforestation, increasing awareness of environmental issues, and helping women in a male-dominated society achieve some economic independence and gain self-esteem. In Kenya, and Africa in general, deforestation and climate change have caused rivers to dry up and the loss of watersheds, leading to drought, poverty, and the inevitable violent conflict that comes with a scramble for ever scarcer resources. Though she was trained as a scientist she believes "cultural revival might be the only thing that stands between the conservation or destruction of the environment, the only way to perpetuate the knowledge and wisdom inherited from the past, [and] necessary for the survival of future generations."[1]

Although Maathai is obviously thinking of a revival of Kenya's indigenous culture, contemporary artists, along with other cultural practitioners elsewhere in the world—many of whom are part of the modern technological society that is most responsible for our ecological woes—also have a great deal to say about our relationship to nature. As *The Forest: Politics, Poetics, and Practice* makes clear, much of it is pointedly critical.

The artists in this exhibition hail from all around the globe. The majority, however, are from countries—the United States, Canada, and Germany, in particular—where forests are important to both the nation's economy and cultural identity.[2] Nonetheless, even though the work included here deals specifically with forests, the subject may be only one part of, or an especially recent subject within an artist's total oeuvre. Largely to aid the visitor, the myriad points of view represented in the exhibition have been loosely divided into three categories: "Politics," "Poetics," and "Practice." But these designations should not be taken as an either/or proposition. The intent was simply to find a way to organize a great deal of fascinating material and to help frame the question of why artists all over the world, especially now, have taken up the subject of forests. It must also be emphasized that it is virtually impossible to pigeonhole any artist into any one group, since most of them have purposefully sought to resist easy classification and are intent on provoking us to think about nature and what art has to say about it on a number of levels.

Many of us, when we think about art and nature, find that painting immediately comes to mind. There are many artists—Anselm Kiefer, Neil Jenney, Alex Katz, Alexis Rockman, Peter Doig, and Laura Owens, among others—who could have been included in this exhibition. But because nature and the act of painting have been so closely associated for centuries, and so often the subject of exhibitions, there has been a conscious choice to focus on video, photography, new media, and sculpture instead. Even so, painting is never far removed from what is on show, and much of the work in the exhibition looks back, at least allusively, to that long history.

The interest of artists in nature (fig. 1), and in ecology specifically, is certainly not new. Nonetheless, it is particularly striking how many artists have recently returned to the subject and received so much attention for doing so. Only a few decades ago, the artists we now call "modernists" made what Robert Rosenblum, in an essay on Mondrian, terms a "complete turnaround, from an espousal of nature and its mysteries, to a rejection of it in favor of an imagery rooted in the utopian city."[3] There has clearly been an about-face since, and as John Beardsley believes, "it may prove in hindsight, that nothing signaled the end of the modern era in art so much as the restoration of landscape to an important position among artists of a particularly venturesome character in the latter half of the 1960s."[4] Beardsley refers not to representational painters, but to artists like Alan Sonfist (who is included in this exhibition), Robert Smithson and Michael Heizer who were determined to take contemporary art out of the gallery and into the outside world.

The 1960s were a time of challenging the status quo, and ecological issues became matters of widespread public debate, beginning with Rachel Carson's surprise bestseller,

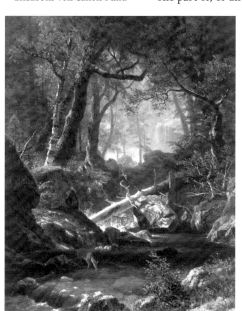

Fig. 1
Albert Bierstadt
Mountain Brook, The White Mountains, New Hampshire
1863
Oil on board
18 1/2 x 15 1/4 in.
Nasher Museum of Art at Duke University,
Museum purchase
Elizabeth Von Canon Fund

Silent Spring (1962).[5] Although ecological issues never really went away between the 1970s and the 1990s, and environmentalists, scientists, lawmakers, and a number of artists remained determined to confront them, the fall of Communism and the victory of Capitalism banished environmental concerns from front page prominence, and much of the world—including nations that have always had the most to lose—embraced globalism, privatization, and the idea of perpetual economic growth. Accordingly, art that took a dissenting and more pessimistic point of view was usually given a backseat in the burgeoning art market, unless it could be readily turned into a big ticket commodity. Multinational corporations had, meanwhile, in advancing business interests that exploited nature (and with only a limited interest in the actual aggregate long term costs), considerable success aggressively asserting their legal rights, while supranational economic bodies, such as the World Trade Organization, World Bank, and International Monetary Fund, often viewed ecological issues as an impediment to their proper work of economic development. Indeed, one recent commentator contended that such entities had come to "have sufficient veto power over domestic laws that it will soon be impossible for any community to prevent the exploitation and export of local resources…, restrict the movement of toxic or hazardous materials, [or] protect wildlife habitat or biodiversity."[6] But, during the past few years, the backlash against globalization and the exploitation of nature has gained momentum. The demonstrations against the WTO in Genoa and Seattle caught the attention of the world, and the urgent issue of global warming and its effects finally has come to the forefront of discussion in science, politics, the media, and popular culture.

Growing awareness of climate change and its potentially catastrophic consequences has challenged artists, and many of us who are not artists, to begin re-thinking our relationship to nature. Trees are a far from insignificant factor in global warming and it is becoming increasingly clear that human survival is dependent on the continued existence of our forests. On the one hand, burning and clearing forests contributes, according to some estimates, 20–25% of all carbon dioxide emissions in the atmosphere.[7] On the other hand, the tropical rainforests of South America are essential to the moderate climate of northern Europe. Collectively, the forests of the world act as carbon sinks to convert CO_2 into oxygen. Some experts estimate that one acre of healthy trees can absorb from two to five tons of CO_2 per year, and produces four tons of oxygen, with rainforests generating upwards of 40% of the world's total oxygen supply. Additionally, of all medicines prescribed in the United States, at least 25% have active ingredients obtained from rainforests, and over 90% of plants used by their indigenous

people have not yet been adequately studied.[8] Nevertheless, despite the recent awakening to the problem, logging, paper production, agriculture, ranching, mining, industry, development, tourism, and geometric population growth have continued virtually unabated,[9] and it is now estimated that more than half of the world's original six billion acres of rainforest have been destroyed. Half or more of what is left could be gone by 2025 if the present level of activity continues.[10]

The role of carbon dioxide as an atmospheric "greenhouse" gas—crucial to the moderate and relatively stable temperatures of the earth's climate and necessary to sustaining life—was first suggested by Jean-Baptiste Fourier in the 1820s. By the end of the 19th century, in the wake of increasing industrialization, scientists began to speculate about what consequences changes in the relative concentration of atmospheric CO_2 might have, and the Swedish scientist Svante Arrhenius was the first to make a mathematical model to explore the potential climatic implications of a doubling of the global CO_2 level (an event, he blithely predicted, use of fossil fuels like coal might take upwards of 3000 years to effect and might, moreover, be a good thing).[11] In the century since, science has established that the rate of observable increase in greenhouse gases has been far greater than Arrhenius imagined possible, and that the impact of worldwide industrial activity has been its primary cause. While detailed measurement of atmospheric CO_2 levels dates back only to the 1950s,[12] scientists have ingeniously used polar ice core and sea sediment samples to infer a remarkably detailed history of the earth's climate, going back several million years. For some 6000 years, up until the 1780s, CO_2 remained a stable 280 parts per million (ppm). By 1930 it had climbed to 315 ppm. And in the period since, atmospheric CO_2 has risen from 330 ppm in the 1970s to 360ppm in the 1990s, and to 380 ppm today. Current models predict we may well reach 500 ppm by 2050. And with the advent of highly sophisticated computer modeling, scientists have taken up the task of predicting future changes in polar ice, sea level, rainfall, and droughts, and of attempting to model what phenomena—for example, the melting of the Greenland ice sheet—once underway cannot be reversed.[13]

Alarm over the implications of CO_2 data has been relatively slow to spread from the legitimate scientific community to the public, although studies in the United States and other countries, many under government auspices, have built a compelling case. In part, this is because the wealth of richer countries, such as the United States, depends on our continued use of fossil fuels (and any restriction on this use would be certain to put us at a short-term competitive disadvantage in global trade), and in part because it is extremely difficult to predict exactly when or where changes

in the climate's temperature will begin to translate into events, like significant change of sea levels or long term drought patterns, with obvious and profound human consequence. Moreover, the chain of causation is difficult for most of us to imagine—from a few degrees increase in average worldwide temperatures to the whole of Holland or most of Manhattan being submerged under hundreds of feet of sea water, or the continental United States growing as arid as the Sahara. Nor can most of us imagine, except in terms of a Hollywood disaster movie, how global politics might change or what sort of regional conflict might result if, for example, a basic resource like fresh water was to become very much scarcer than it is today, and not for a season or two but for decades at a stretch. This process of global warming seems less urgent to many of us because even the most pessimistic experts acknowledge that it might take several centuries to play out; we are also accustomed to thinking of more immediate threats, like nuclear war or world wide epidemics. Whether it is true or not, climate change seems intuitively, to many of us, the sort of threat that must ultimately be manageable, something that human adaptability and advanced technology will surely solve when the time comes.

And it is around this question, at least, that there remains room for reasonable disagreement about how soon "too late" will arrive, and about the equities, now and in future, of how and among whom the costs of remedial action should be divided. Accordingly, the current U.S. administration continues to deny the urgency of global climate change and—evidently taking solace from such groups as the International Policy Network, which contends that global warming is a "myth"—chose to cite U.S. economic interests when in 2001 it stood alone in its refusal to sign the Kyoto Protocol and agree to a strict timetable for lowering current greenhouse gas emissions.[14]

What cannot be denied is that global warming is a hot political topic—one that is likely to become more so in coming years, and in which the debate will likely be cast in increasingly polarized terms. The important British meteorologist and policy maker, Sir John Houghton, maintains he has "no hesitation in describing global warming as a weapon of mass destruction."[15] And many poor countries have begun to cast the issue as no longer simply an environmental problem but as "an assault on their basic human rights."[16] In looking ahead to their future economic and industrial development, some countries have begun to speak of CO_2 emissions with a per capita logic, and point out that the United States with only 7% of the world's population has been responsible for almost a quarter of the 30% increase in emissions from burning coal, oil, and gas, of the past 100 years.[17]

But then, in many ways the politics of the environment has long pitted those who see the need to preserve nature for the common weal against those who stand to benefit from the exploitation of natural resources in the short term. Even in classical times, deforestation was a political, economic, and social issue. George Perkins Marsh, in *Man and Nature*, argues that "the destruction of the woods was man's first physical conquest."[18] In *Collapse: How Societies Choose to Fail or Succeed*, Jared Diamond suggests that ecological neglect was responsible for the ultimate failure of societies such as the Ancient Maya, the Greenland Vikings, and the Anasazi Native Americans. And the grimmest chapter in his book chronicles the fate of the Easter Islanders, who so deforested their land that they could no longer build boats to escape a society that had fallen into a spiral of war, famine, and cannibalism.[19] Historian J. Donald Hughes contends that "the Romans' failure to adapt their society and economy to the natural environment in harmonious ways is one of the causes of the decline and fall of the Roman Empire, if not in fact the basic underlying one."[20] While, he goes on to suggest, the Greeks "contributed to their own decline" when they lost most of their forests between 600–200 BCE due to logging and grazing of goats.[21]

At least a few Latin and Greek writers offer evidence to support Hughes' view. Writing in the 3rd century BCE, Quintis Ennius notes tree cutting in his history of Rome, and in the *Critias*, Plato states that "what now remains [of Greece's forests] compared with what existed is like the skeleton of a sick man."[22] Finally, as we know, the fabled Cedars of Lebanon were an early casualty of urban development that vanished millennia ago. And, while the causes remain still subject to debate—a sudden change in long term drought patterns due to natural causes (like a shift in the earth's orbit) or poor policies of land management—much of the ancient Fertile Crescent has long been harshly arid.

Almost all early cultures revered nature and fearfully regarded its willful destruction as an act of provocation sure to result in the wrath of their gods. In the early epic *Gilgamesh*, the Mesopotamian king and Enkidu, his wild man counterpart, achieve fame by slaying Humbaba, the guardian of the Cedar Forest, and cutting down his trees. After their transgression, however, Gilgamesh and Enkidu regret and repent these acts, and use the tallest cedar for the door of a temple built to placate the gods. The character of Enkidu would seem to be a fairly universal and enduring archetype. The "Green Man," whom he strongly resembles, appears in Chinese and Indian writings as early as the second century BCE. And similar Green Men (and the less common Green Women), frequently appear in carvings, both Pagan and early Christian, throughout the British Isles.

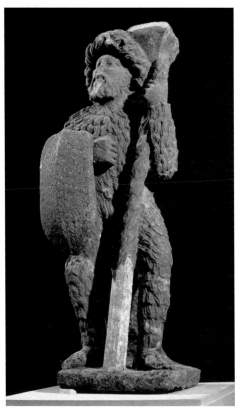

Fig. 2
Statue of a Wild Man
Germany
15th century
Red sandstone
40 x 15 in.
Nasher Museum of Art
at Duke University
Brummer Collection
Photo by David Page

Consistent is their portrayal in positive terms—often, and quite early, alloyed with regrets for the cost of progress and the woes of civilization. Tacitus celebrates the "wild" tribes of Europe as pure and unspoiled (in much the same spirit Montaigne will praise native Americans less than a century after Columbus's "discovery" of the New World, and Rousseau will create his "noble savage" in the 18th century). The unknown rider who arrives at King Arthur's table in *Sir Gawain and the Green Knight* is closely related, as is the medieval "Wildman" who recurs often in the art of Northern Europe (fig. 2). And even the legend of Robin Hood may be seen as a later elaboration on the character. As may the Jolly Green Giant in our own time.

Duke University has been an important pioneer in the study of every aspect of forests, their ecology, preservation and management. Duke's campus today is surrounded by the nearly 7,000 acres of the Duke Forest, where hundreds of studies have been conducted in its 70-year history.[23] William H. Schlesinger, dean of the groundbreaking Nicholas School of the Environment and Earth Sciences, who initiated and co-directs the Free Air Carbon Dioxide Enrichment Experiment (FACE), is currently conducting important research on global warming in the Duke Forest. The purpose of this project is to study and predict how the forest ecosystem will respond to the CO_2 levels projected for the year 2050 and come up with solutions to the resulting problems, including increasing forests' abilities to function as carbon sinks. The Duke Forest is also used for research in gas flux, watersheds, and forest dynamics, and NASA remote sensing devices are used to detect changes to its ecosystem. Duke history professor John F. Richards is an expert in the field of environmental history and has organized two important conferences on global deforestation for the university.[24] And, perhaps most importantly, at a time when debate about the environment has grown increasingly polarized and the urgency of formulating and effecting a coherent global policy has grown so imperative, Duke and its faculty stand apart from the voices of denial on the one hand and doom on the other. We are, as Duke University professor Rob Jackson, director of Duke's Program in Ecology, writes in *The Earth Remains Forever*, at a crucial crossroad. "Likely not the end of the world, but certainly at a decisive moment, when the stewardship and vision that we show today will help determine the type of world that our descendants inherit."[25] Accordingly, it is appropriate that the Nasher Museum of Art's inaugural exhibition of contemporary art should be devoted to so important and timely a subject.

Fig. 3
Joseph Beuys
Dia Art Foundation's continuation of Beuys' *7000 Oaks* project.
1988–1996
Twenty-three trees of five varieties paired with basalt columns.
West 22nd Street between 10th and 11th Avenue, New York, NY.
Photo © Robert Ransick

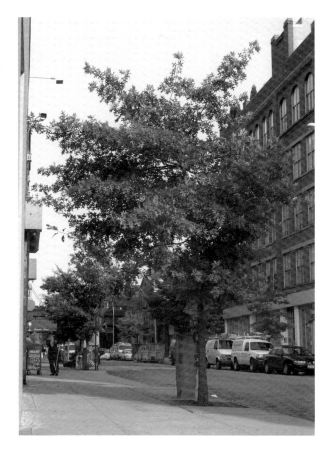

Politics

IT HAS BEEN SAID THAT ART is always political—even when an artwork appears to be solely emotional, aesthetic or spiritual, when one looks at the time and context of the art's making, additional layers of meaning emerge. For instance, even if we know quite a bit about 19th-century European history, we might not think of the work of Caspar David Friedrich, the great German painter of forests, as political. However, "he was an ardent patriot," and his pictures of bleak winter landscapes would have eloquently conveyed to his countrymen his despair at a time when "the dominance of Napoleonic imperialism seemed heaviest."[26] But then art has a long history of making use of nature symbolically—almost universally in religious paintings prior to the Renaissance, and later in more secular works like portraits. In the fresco said to be by Leonardo da Vinci in the "Sala delle Asse"(a room in the Castello Sforzesco in Milan), for example, the forest of mulberry trees that appears there is not simply decorative. The black mulberry fruit is a reference to the duke who commissioned it, Ludovico "il Moro" (the Moor) Sforza. The intertwining of the Este lilies with the mulberry branches is a witty allusion to his reign and the diplomatic joining of forces with another important Italian ducal family through his marriage to Beatrice d'Este. That said, both these works are also triumphs of visual imagination created by avid and observant naturalists, and—like the works in this exhibition—must be read on many different levels.

Although JOSEPH BEUYS is usually regarded as the quintessential political artist, his lifelong interest in nature myths, pre-Christian rituals and symbols, and the German passion for forests also recur frequently in his work. A member of the Luftwaffe in the Second World War—who claimed to have been rescued by Tartars in the wilderness of the Russian Urals after a plane crash[27]—Beuys came to despise the ideology of National Socialism and became a political activist after the war. Nevertheless, he embraced and tried to rehabilitate the romantic German notion of nature that had formed one part of the theoretical basis for the Nazi faith in the German people's racial superiority. The idea of an invincible people attuned with nature can be traced back at least as far as Tacitus's *Germania*. In it he offered a critique of the corruption of his civilized Roman world and a begrudging admiration for the primitive Germanic tribe, one of Rome's most tenacious foes. Despite the fact that Germany had been methodically deforested for years, National Socialism's obsession with the idea of a primal forest continued to thrive. It is interesting to note that the discipline of forestry began surprisingly early, prior to World War I, with the support of the German Kaiser; later, after the Nazis' rise to power, it was introduced into the school curriculum; and one of Hitler's most cherished goals was to create a vast forest that would stretch from the Rhineland to Russia.[28]

This dialectic between a pure and primordial past and the excesses of modern life, as posited by Tacitus, is also at the heart of Beuys' work. He so identified with Germany's nature-worshipping past that he often falsely claimed to have been born in the ancient town of Kleve rather than the modern industrial city of Krefeld.[29] In addition to his trademark boots and hunter's vest, many of his performance pieces employed animals such the hare and the coyote, symbolically. Beuys was also a founder of the German Green Party and ran an unsuccessful campaign to represent the party at the European Parliament.

Perhaps Beuys' best known work was his *7000 Oaks* project, conceived for the 1982 *Documenta 7*, a prestigious international exhibition held every five years in Kassel, Germany. His plan called for the planting of 7000 oak trees around the city, each one placed next to a basalt column—a task that took nearly five years to complete. Beuys' use of oaks and basalt in combination was almost certainly a product of his fascination with the Druids, who venerated oak and basalt, and are generally believed to have built Stonehenge. Beuys might have even been familiar with the theory of Sir James Frazer, author of *The Golden Bough*, who considered the configuration of Stonehenge to be based on that of a forest.[30] The planting of the 7000th tree took place at the opening of *Documenta 8* in 1987. After Beuys' death, the Dia Art Foundation in New York planted twenty-three more trees with accompanying basalt columns—these may still be seen on 22nd Street in the city's Chelsea gallery district (fig. 3).

In this exhibition, Beuys is represented by *Rettet den Wald* or *Save the Woods* (cat. 26), a lithograph commemorating an action staged in 1972 to protest a proposed country club that would have destroyed part of the wooded lands outside of Düsseldorf where he lived and taught. Beuys and his students and followers painted crosses and rings on the threatened trees and ritually swept the forest floor with brooms to symbolically sweep away the capitalist greed and bourgeois notions that they believed would lead to the destruction of nature.

LOTHAR BAUMGARTEN, a student of Joseph Beuys, shared many of his views about nature, and later became an advocate for cultures that have a special bond with it. His seminal film, *Der Ursprung der Nacht (Amazonas-Kosmos)* or *The Origin of the Night: Cosmos of the Amazon* (cat. 2) was made between 1973 and 1977. Baumgarten used a Tupi Indian myth about the division of night and day in this meditation on the Amazon rainforest. Only at the end is it revealed that the film was shot not in the forests of South America, but in the woods and swamplands on the periphery of Düsseldorf and Cologne. The film is, accordingly, a "faux document of the Amazon. One that hinges on an act of intentional mis-naming… [and is] quite clearly, a forest of symbols."[31]

The narrator of Baumgarten's tale is a bridegroom who is off on a quest for the night—although "night" does not as yet exist. He tells of a journey back through time, and a botanical garden in a virgin forest where rubbish and stagnant pools are now found. Baumgarten says that his film is "a journey through the ciphers of myths, the smell of books, the metamorphosis of forms and sounds. The rubbish, the objects and spaces of the most immediate surroundings are a melancholy meeting of nostalgia; the remains of paradise in El Dorado, the dead Rhine forests at the edge of town."[32] His film is not literary in the traditional sense and is based on images and forms that Baumgarten devised. It is "as multitudinous as the layers of the tropical rainforest and its myths, its smells and its sounds. It is a meditation on the psyche of things; the morphology of objects and vegetation. Ethnographic, literary, art historical and botanical quotations, signs, marks, and colors, are all enmeshed with one another. And they change and overlap in visual, semantic and phonetic layers."[33]

Making this film inspired Baumgarten to seek out the real rainforest. And he spent the years 1977 to 1980 living for extended periods of time with the Yanomami Indians in the Northwest Amazon region spanning Venezuela and Brazil. After months getting to know them, Baumgarten began to photograph, film, and record the Yanomami and their habitat, focusing on the deforestation and other damage done by the gold-mining industry.

The Yanomami number 12,500 and are the largest indigenous population of the Amazon to have preserved its traditional culture intact. They had no contact with the outside world until the 20th century when miners, missionaries, and gold prospectors discovered them. All the ills wrought by civilization were visited upon them with the result that their numbers plummeted and their homeland was for many years in peril.[34] Because of an outpouring of support for the Yanomami from around the world, in 1992 the government of Brazil gave them 37,000 square miles of forest as a private reserve.

The sound artist STEPHEN VITIELLO also spent time with the Yanomami, at the invitation of the organizers of *Yanomami, Spirit of the Forest*, an exhibition sponsored by the Fondation Cartier pour l'Art Contemporain in Paris in 2003. This project sought to make a connection between the spiritual imagination of the rainforest's indigenous people and the creative processes of contemporary artists. Vitiello, Wolfgang Staehle (who is also included in this exhibition), and several other artists were sent to Brazil to collaborate with shamans in the village of Watoriki. *Hea and Binaural Recordings: Yanomami Watoriki* (cat. 22) is the result of Vitiello's investigations. He discovered that for the Yanomami, each sound has a particular meaning and is part of a complex web of nature. *Hea* is a Yanomami term for assigning symbolic meanings to sounds. Vitiello says of his experience and of this work, "I don't want to pretend to be a spokesperson for the culture or the forest. [My work] is a kind of sensory sonic impression. But, the shaman said, 'This is what you should listen for, this is the kind of meaning we find in a sound.' It's not just some expert in sound standing on the edge of a forest; it's a privileged view that we were given, even if it was very limited."[35] Visitors to the exhibition can listen to Vitiello's five compelling sound works on headphones. His sophisticated binaural recordings faithfully capture the sounds of the Brazilian rainforest during a 24-hour period and are juxtaposed with stories told by the shamans with whom he collaborated.

SERGIO VEGA changes the familiar opening of Canto I of *The Divine Comedy*–Dante Alighieri's verse masterpiece of a vividly imagined tour of Hell, Purgatory, and Heaven–from the 'dark woods' of Tuscany in 1300 to the jungles of South America in a series of photographs entitled *Within Dante's Inferno* (cat. 31).[36] Like Baumgarten, Vega is concerned with the rainforests of the southern hemisphere as a lost paradise, but he views the rainforest as a cultural construct. His *El Paraiso en el Nuevo Mundo* (*Paradise in the New World*) is a project consisting of photo essays, dioramas, sculptures, architectural models, videos, and installations. Vega was inspired by the 1650 text of Antonio de Leon Pinelo, a Spaniard who spent years researching every topic related to the Biblical Earthly Paradise in an effort to prove that the Garden of Eden was located in the rainforests of South America.[37] Vega adopted Pinelo's thesis and traveled to Brazil with his camera, living the parody of the heroic artist portraying otherness. But instead of Paradise, he discovered the effects of colonization.

Keenly aware that the very act of photographing is a colonizing practice, Vega explains that his work is:

An attempt to bring forward my own interpretation of historical and contemporary systems of representation

employed to picture the Americas. While scrutinizing an array of cultural formations, I focus on the iconography employed in nature documentaries, the ethnographic and naturalist museum strategies of representation and display, and the imagery produced by the industries of tourism. In addition, I examine the colonial baroque, romanticism and modernist periods and their contributions to the world of Edenic fantasies. By speculating on the ways in which colonial fantasies were adopted by the colonized to build their own culture, I constructed an opinioned portrayal of the site. A tragicomic scenario where the myth of Paradise coexists today with the mixed blessings of the developing world.[38]

Iñigo Manglano-Ovalle also refers to Dante's *Divine Comedy* in a series of works, each involving a modern-day historical figure. In this exhibition, we find the protagonist in the artist's video projection (cat. 3) to be J. Robert Oppenheimer (played by a look-alike), a character who beckons us, like Dante's Virgil, into a nuclear hell. Instead of the panther, lion, and wolf that confront Dante in the forest, Oppenheimer's beasts—that may be unleashed at a moment's notice—are the creatures of his work as director of the Manhattan Project, where he led the team that invented the atomic bomb. Oppenheimer was later expelled from the Atomic Energy Commission for his supposedly leftist leanings after he became a vocal critic of the hydrogen bomb and the escalation of weapons development.

Manglano-Ovalle explains, "What's interesting to me is the moment when philosophers, artists, and scientists work on such high aesthetic planes that they disconnect themselves from larger social concerns, and then it implodes."[39] In this video loop we see Oppenheimer locked into a repeating sequence of Hitchcockian pans and zooms in the midst of a forest of prehistoric ferns. What seems to be an Amazonian jungle was actually shot at landscape architect Jens Jensen's famous Fern Rooms at the Garfield Park Conservatory in Chicago. The notion of replicating nature was so new that when it first opened to the public in 1874, visitors to the Fern Rooms thought a glass structure had been built over an existing forest. In Manglano-Ovalle's video, Oppenheimer is caught forever in Dante's hell, perpetually doomed to listen to the whistle of an ICBM launch.

An-My Lê's photographs in the exhibition are from her series *Small Wars* (cat. 7 and cat. 8, back cover) and are a simulacrum of another kind of hell. The woods of North Carolina and West Virginia—where groups of war re-enactors gather together in the summers to stage battles from the Vietnam War—serve as a stand-in for the jungles of Southeast Asia. Lê was born in Vietnam but has little memory of the conflict from which she escaped as a child. Her perceptions of the war are gleaned less from personal experience and more from family photos, black and white newspaper photographs of the time, and Hollywood films. During an Internet search, Lê discovered a website created by Vietnam War re-enactors, and contacted the group soon after, who invited her to join them on their outings. Veterans, their families, military personnel, those who missed out on a combat tour, and even Vietnamese who have immigrated to this country play parts in these dramas. Lê explains:

> [The war-enactors] are driven by deeply personal and complex psychological motivations. In comparable ways, the re-enactments allowed me to delve into my personal experiences of war and attendant adolescent fantasies about soldiers in uniform. Through the exploration of war imagery and the aesthetics of combat photography, I have begun to recast the war as a smaller, safer, and ultimately resolved conflict. The re-enactors and I have each created a Vietnam of the mind and it is these two Vietnams that have collided in the resulting photographs. Here I experience Vietnam in America as I experienced America in Vietnam: worlds of conflict and beauty.[40]

Collier Schorr also deals with war in her *Forests and Fields* (cat. 29) series. In these unsettling photographs, vulnerable and androgynous young men who resemble fashion models are dressed in military garb (in some cases Nazi uniforms), and pose in the woods of Germany for her camera. Schorr, an American Jew, spends extended periods of time in Germany, where relics of World War II such as helmets are still being uncovered on farmlands and in forests. She says, "In a sense, perhaps the pictures were an attempt to flush history out into the open.… These pictures are as much about what I see, either through the veil of fantasy or an inherited anxiety."[41] The National Socialist regime celebrated the ideal of perfect masculinity, rewarding the bravery of young men who bonded together to fight and sacrifice their lives for the Fatherland. While the Nazis provide an extreme example, wars are only made possible by the remove from reality which turns the horrors of combat into a "terrible beauty."[42]

Schorr's work also deals with gender politics, and she appropriates the male gaze to reveal the latent homoeroticism of such war fantasies. The setting for her photographs is as pertinent as her protagonists. Forests have always figured in conflict—as a site for actual battles, as a source of refuge, and as a place for clandestine activities. Accordingly, Schorr's adolescent soldiers could be simply resting from their duties, or they might be deserters eluding

capture, or even awaiting a rendezvous with a male lover. Both historically and in art, forests have at once hidden secrets and offered refuge. The unmarked forest graves of the last Romanov Czar and his family remained a secret for nearly ninety years, and were found only recently, while during World War II, forests offered safety to partisans, deserters, and escapees from both concentration camps and prisons. In literature, Jerzy Kosinski's *The Painted Bird* chronicles the desperate life of a young boy hiding in the woods from his persecutors, and before Kosinski, the heroine of Nathaniel Hawthorne's *The Scarlet Letter*, Hester Prynne, takes refuge in a forest with her illegitimate daughter.

Jamaican-born RENÉE COX is well known for the self-portraits in which she plays various characters. Her notorious *Yo Mama's Last Supper*—in which Cox appeared as a nude female Christ surrounded by black male disciples—received considerable attention when it was shown at the Brooklyn Museum and provoked the ire of New York's mayor Rudy Giuliani. But, as the star of her own photographs, Cox joins the ranks of important women such as Claude Cahun, Cindy Sherman, and more recently, Nikki S. Lee. In her recent photographic series *Queen Nanny of the Maroons*—of which *Ambush* is a part (cat. 23) is shown here—she also deals with war, celebrating the empowerment of black women, and the outsider who defies the norms of society. Queen Nanny, an 18th-century Jamaican, was the military leader of the Maroons. The Maroons were freed and escaped slaves who banded together, and fought the British colonizers of Jamaica soon after the British ousted the Spanish at the beginning of the 18th-century. Queen Nanny, immortalized in song and legend, remains today a Jamaica hero, and her descendants still own the property she conquered. A fearless, bloodthirsty Ashanti warrior, she fought her enemies in the lush rainforests of Jamaica by disguising her soldiers as trees.[43] They pounced on the unsuspecting British who, burdened by red uniforms and heavy guns, were forced to march single file through the jungle. In this image, Cox portrays Queen Nanny—who is sometimes credited as the inventor of camouflage—as she peeks through the dense jungle foliage, spying on the enemy.[44]

HOPE SANDROW's photograph *Untitled Observations, July 29, 2004* (cat. 25), was taken at the Trout Pond Forest Preserve on Long Island, near Southampton, New York, and reflects her concern with ecological issues. Trout Pond is a body of fresh water within an unspoiled wooded zone, and the stream which feeds into it comes from the aquifer layer that is essential to the fresh water supply of this community of lavish summer homes. The health of the preserve is considered vital to the health of the community as a whole.

Nonetheless, Southampton development has increased exponentially in the past decade as a result of skyrocketing property values and its sustained status as a fashionable summer address among a top tier of wealthy bankers, businessmen, lawyers and celebrities. Summer residents and upscale local developers have continued to build on unoccupied acreage, and, in Sandrow's view, the local government has made some very questionable decisions that adversely affect the ecosystem. Her work also has a strong feminist bent. And, says Sandrow, this project "follows my work process of an investigation evolving from the feminine-personal towards a 'world' view."[45]

This work is from Sandrow's continuing series *Observational Findings* and a part of her larger *Space(Time)* project, in which she takes pictures by means of a digital camera attached to a telescope set on a motorized tripod that tracks the moon's transit. The camera is focused on the forest landscape and her own body, while the telescope is aimed at the full moon. Sandrow explains, "The projection maps the observer's figure on the ground while the camera documents the dynamic positioning of the observer to the earth, moon, stars, and sky. The documentation is a description of space in relation to the observer, in the form of large scale landscape panoramas as well as singularly focused studies taken at close range."[46] The process of inverting the image of the moon mirrors the action of the eye's retina, and also refers to the traditional artistic and scholarly practice of employing a *camera obscura* to make images copied from projections. According to Sandrow, Galileo made wash drawings of the moon and sunspots using a *camera obscura* to project telescopic images onto paper.[47] Her work is also reminiscent of the 19th-century German artist Caspar David Friedrich's famous painting *Two Men Contemplating the Moon*.

Australian artist ROSEMARY LAING makes what seems impossible manifest in her *Groundspeed* photographic series— particularly in *Red Piazza #3* (cat. 24), included in the exhibition. Her luscious, beautiful, yet paradoxical images are haunting. Laing's painstaking project-based work is often the result of research and collaboration with professionals such as airline personnel, film stunt people, members of the military, and in the case of *Red Piazza #3*, Australia's biggest rug manufacturer, Feltex. At first glance, this panoramic photograph—of a Victorian-style floral chintz carpet in a lush forest— seems digitally manipulated. Not so, although Laing is not necessarily opposed to altering images and has done so in other work. For this series, she chose three sites in the Australian wilderness and three different carpets, carefully positioning them to make it appear that the trees have grown out of the rugs. She even scatters leaves and branches to complete the illusion. Laing's work is often con-

cerned with the dichotomy of nature and the domestic, the organic and the synthetic, and in these works, the simulated appears to spring seamlessly from the real, or vice versa. The incongruity of the work is also typical of her oeuvre where brides fly and suites of modernist furniture appear in the desert. In the view of critic George Alexander, "the carpet designs, drawn from popular fabric patterns of her youth, evoke suburban parlours of ladies' bedrooms. Involuntary close-ups of soul-snaring designs conjure comfy sympathy or a malignant torpor associated with indoors, like in the 'burbs' in front of the two-bar radiator or black and white TV with rabbit ears."[48] The Victorian chintz is also a reminder of Australia's colonial past and the displacement of aboriginal culture. (Ironically, Feltex recently introduced a new line of Maori-inspired designs.) Laing says that the idea of Australia's natural landscape has become something of a media construct and is being steadily replaced by its theme park *doppelgänger*.

ZWELETHU MTHETHWA's photographic portraits of sugarcane cutters (cat. 15) document the pride and personal aesthetics of these impoverished workers, while exposing the negative aspects of economic development in South Africa. In all his work, Mthethwa is sensitive to the dignity of his subjects. He asks them how they want to be depicted and where, and requests that they wear clothing of their own choice when posing for his portraits. He says, "in most of the photographs that come out of South Africa—whether from photojournalists or from artists—I have found the common objective is to sensationalize and to draw attention in a distasteful manner. When I view some of these photographs I cannot help but think of these people who have been photographed as victims of abuse."[49] In contrast, Mthethwa's sugarcane cutters—who are poor and almost certainly exploited—have an air of dignity and carry themselves with elegance. Significant is that these workers are employed by an industry that has replaced the indigenous forests of Africa with green deserts of sugarcane.

According to the *Oxford Companion to Food* (1999), sugarcane is the source of most of the world's sugar, and is the descendant of a now extinct plant probably originating in New Guinea. It was cultivated in Asia, is first mentioned in Indian literature (the word sugar is derived from Sanskrit), and was brought to Europe by Alexander the Great. Columbus introduced sugar to the Caribbean, where it became the area's most important crop, and the first recorded instance of its cultivation in sub-Saharan Africa is in the Cape Verde islands in the early 15th century. The sugar industry in South Africa—much of it on Tribal Authority Lands—is important to the economy of South Africa but its impact has been severely detrimental to forests and wetlands.[50] Sugar is primarily produced for export to industrialized nations, and its cultivation is inextricably linked to colonization. The post-Apartheid government has had some success in encouraging small growers and black ownership, but the sugar industry is still dominated by large white-owned farms and mills.

SIMON STARLING is an itinerant artist, experimenter, amateur scientist, tinkerer and explorer. Something of a Renaissance man, he is fascinated with botany and horticulture, music, architecture, design, and all means of industrial production. Starling is also an avid researcher, interested in nature and process, and the forgotten origins of things. In one project, he transported rhododendrons by car from Scotland—where they are considered weeds—to Spain, their native home. He encourages the viewer to see the product as being much more than the sum of its parts, and to explore the physical processes and ideas that were responsible for its creation. "At the same time," says Starling, "each element possesses a fascinating narrative. . . indissoluble from the whole."[51]

Trinidad House (cat. 30) was undertaken during an extended visit to the island in 2001. Starling was interested in how globalism had affected the local architectural vernacular, and worked with a group of Trinidadians who were building a home. He explains, "in the 1970s there were various experimental forestry projects [in Trinidad] which were designed to create a lucrative viticulture on the island." This involved clearing the indigenous jungle and planting a particularly hardy and fire resistant strain of Honduran Pine. In recent years this activity has been heavily criticized since it creates conditions that are not favorable to the local flora and fauna. He explains:

"[My] photographs document the building of a house with the remnants of this now outmoded forest at a point of abrupt transition—from the original jungle and the introduced pine forest. The house is itself a piece of hybrid architecture, fusing a European style log cabin with Trinidadian vernacular techniques. The sequence of images moves up the hillside from the jungle into the pine forest and towards the house. It concludes with a view from inside the house back down the hill to the jungle and the town of Port of Spain beyond."[52]

Poetics

"POETICS" IS USED IN A BROADLY inclusive way in the context of this exhibition with reference to a variety of primarily verbal cultural manifestations including legends, fairy tales, myths, Biblical stories, other religious narratives, literary works, including poetry, plays, and even operas,[53] as well as more modern enterprises like cinema and contemporary music. As earlier emphasized in this essay, politics and poetics are often impossible to separate, and a poetic guise has frequently been employed by artists intent on getting an inflammatory political message past the censors.

As a cultural construct, the forest has historically been regarded with a measure of ambivalence.[54] And although celebrated as a spiritual place it has often simultaneously been feared as the abode of evil. In either case, it has frequently been viewed as the domain of the divine or supernatural.

Initially, at least in the New World, fear of the wilderness may have owed something to experience. And for the early American colonizers, the forest must have seemed a forbidding place, where a traveler might get helplessly lost, die of exposure, be attacked by wild animals, or set upon by Native Americans. On the other hand, any one of these possibilities might almost equally overtake them at home during the early centuries of exploring and settling the American continent. How much the folklore of the Old World might have contributed to our forebears' ambivalence is hard to say, but certainly the compilations of traditional folklore that have come down to us from such sources as Charles Perrault (whose versions of *Little Red Riding Hood*, *Sleeping Beauty*, and *Cinderella* have been extraordinarily popular since the time of their publication) and the Grimm Brothers suggest that forests have a long tradition of being regarded as sinister places, where goblins and ghosts reign, witches congregate, and children are routinely abducted or eaten by monsters.

More serious works—or works more clearly aimed at an adult audience—also have a long history of presenting forests in a dark and supernatural light. In Nathaniel Hawthorne's short story *Young Goodman Brown*, for example, the main character keeps an appointment with Satan deep in the forest. And of course the gothic horror genre—whether 19th-century novel or 20th-century film—would be unimaginable without isolated castles surrounded by wild forests and the nocturnal howl of wolves.

On the other hand, forests have also been seen by many cultures as a place for spiritual purification and even divine revelation. Buddha sought knowledge among the hermits and sages who lived in the forests of his kingdom, and eventually found enlightenment under a Bodhi tree deep in the woods.[55] And, as discussed earlier in this essay, forests have, in literature as in life, always been regarded as a sanctuary for outsiders of every kind at odds with their society.

Finally, the artists here continue the long tradition of celebrating Green Men and those who are noble but not civilized.

JENNIFER BOLANDE's suite of iris prints *Forest Spirits* (cat. 1) —derived from a 1930s postcard depicting a wooded path on a private estate in Ireland—is a high-tech, grown-up take on a child's imagining goblins in the wallpaper. She computer-scanned the card, then folded, spliced, and mirrored the image to create a haunting fairytale forest of witches, elves, demons, ghosts, trolls, castles, and weird animals. Like Max Ernst's frottages of the late 1920s (particularly those with forest subjects), where fantastic images emerge from rubbings, Bolande's phantasms seem like windows into the subconscious.

But as Tim Maul—the artist who sent Bolande the postcard, and a frequent visitor to Ireland—explains, there is more. According to Maul, the place depicted in the postcard is the site of a Bronze Age burial mound. More recently, it was the setting of a deadly IRA ambush and a famous murder, and is still avoided by local residents as cursed. "I see [Boland's] figures as 'Green Men'—not-so-benevolent Celtic forest presences that peer out of everything from Irish war-lord tomb carvings to the leafy details of 13th-century French cathedrals. In rural Britain a Green Man pub is evidence that the 'old beliefs' still have currency in whatever town you may happen to be in."[56]

PETAH COYNE's *Paris Blue* (cat. 6), like most of her work, is covered with wax-dipped flowers and branches, evoking the floor of an enchanted forest. Her sculptures are often adorned with woodland creatures such as squirrels and birds (both faux and real) acquired from junk shops and taxidermists, and they frequently contain secret and precious objects of personal significance hidden among their branches. Coyne refers to her sculptures as her girls and explains that she imagines them coming to life in her studio whenever she leaves them alone for the night. Hidden in *Paris Blue* is a figure of the Virgin Mary nestled in the foliage. Coyne frequently incorporates statues of saints into her work— usually chipped and damaged seconds she buys in religious supply stores and lovingly rescues and enshrines.

Raised as a Catholic, she rejected the Church's repressive dogma and sexist attitudes as an adult, but has continued to embrace the sensuality and baroque sensibility of Catholic art and rituals, along with the Church's longstanding concern with the extremes of life and death, beauty and decay. One early work was a representation of a giant nun she sited on a highway in Texas. Her use of dripped wax to enhance her sculptures began after a friend sent her special votive candles from Rome blessed by the Pope. In a way, Coyne's work anticipated the recent burgeoning fascination with the feminine divine as evidenced by such national bestsellers as Dan Brown's *The DaVinci Code* and David Guterson's *Our Lady of the Forest* (a novel set against the contemporary backdrop of the failing logging industry in Washington state, in which the Virgin appears to a run-away teenager). Her work also alludes to the phenomena of Marian visions, many of the most famous of which, such as those at Lourdes, Guadalupe, Fatima, and more recently Medjugorge, have occurred in the woods or elsewhere in nature.[57]

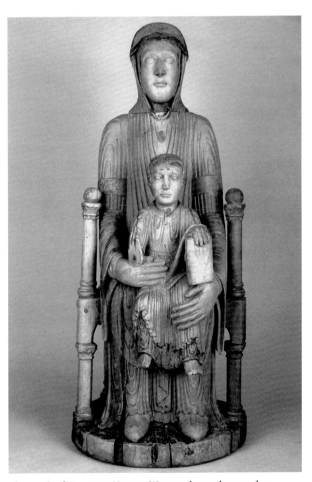

Fig. 4
Virgin and Child
Auvergne, France
12th century
Wood
28 x 11 7/8 in.
Nasher Museum of Art
at Duke University
Brummer Collection

The work of PALOMA VARGA WEISZ also embraces the sacred, and refers to both the pagan tradition and those elements of Christianity that sprang from it. Her *Waldfrau Getarnt* (*Forest Woman in Camouflage*, cat. 21) is both of the woods and literally of wood. Carved from limewood (also known as linden wood), she sits perched with her child on a tree trunk that was specially harvested from the Duke Forest. Pre-Christian Germans are thought to have worshiped limewood as the abode of benevolent spirits, and it was prized by Gothic and Renaissance sculptors who used it for important carvings, especially effigies of the Virgin and altarpiece saints. Varga Weisz's *Waldfrau* employs a medieval vocabulary of forms and iconography, and can be compared stylistically with the wooden *Virgin and Child* from the Nasher Museum's collection (fig. 4). Varga Weisz's woman, however, is not a Madonna and, instead of blue, she is draped in camouflage to conceal her from forest predators. She gazes lovingly, not at the perfect infant typically depicted in Christian art, but at a primordial child of nature—a gnarled, knotted creature, part human and part animal— who is more reminiscent of pagan myth or the stories of the Grimm brothers than of the Holy Infant.

KIKI SMITH is well known for her work dealing with the fragility of the body and feminist politics. In the late 1990s, she turned to *Little Red Riding Hood* for inspiration, adding its heroine to her iconic female pantheon—which includes Eve, Snow White, and Alice in Wonderland. There are a number of versions of this famous tale, derived from folklore, including the familiar *Little Red Riding Hood* of Charles Perrault, *Little Red Cap* of Jacob and Wilhelm Grimm, *Little Red Hat*, an Italian-Austrian version, and a French tale, *The False Grandmother* (in which the villain is an ogre, not a wolf). As a metaphor for sexual awakening, all these stories tell of a naïve young girl who ventures alone into a dark forest, and who is so "pure" that she is entirely unaware of the dangers that lurk there as she stops to pick flowers. The Grimm brothers' two variations of the story end happily (the girl and her grandmother are cut out of the wolf's stomach by wood cutters; the grandmother tricks the wolf into falling off the roof of the cottage and he drowns in a trough). In the more familiar Perrault version, both Little Red Riding Hood and her grandmother are devoured. And, in what are believed to be earlier folk versions, the girl is tricked into eating the flesh and blood of her grandmother before she is herself consumed.[58]

Smith's *Wolf* (cat. 11) is a cast of a life-size bronze wolf holding a single red glove in his mouth (based on drawings the artist made at the Peabody Museum at Harvard). Is this all that remains of Little Red Riding Hood after she has been devoured? Or is the wolf the girl's faithful canine companion who has retrieved her dropped glove, and is now chivalrously offering it back to her? This wolf, unlike the anthropomorphic threatening male character of folklore, seems more a noble creature of nature than a villain. The fact that Smith

has pictured girls and wolves as companions in other works suggests the latter interpretation is correct. Helaine Posner has proposed that Smith's Little Red Riding Hood and wolf are "colleagues in the effort to protect their fragile domain, whether it is understood to be the enchanted garden or, in contemporary terms, as our fragile environment."[59]

PHYLLIS GALEMBO's photographs also show innocent girls and tell the story of *Little Red Riding Hood*. These pictures were included in the exhibition *Dressed for Thrills* of her collection of 500 vintage American Halloween costumes.[60] Most scholars trace the origins of Halloween to the Celtic Samhain Festival which marked the end of the growing season, and involved the Druids performing rites in the woods. Although the American Halloween tradition has evolved into a purely secular children's holiday—and more recently into a celebration of otherness in elaborate parades in gay communities around the country—its roots can be found in an ancient culture that regarded nature respectfully, as both nurturing and terrifying.

Galembo uses her costume collection in her work, and not unlike a film director/producer, she casts models, gathers props, and designs the sets she uses for her photo sessions. The costumes in *Red Riding Hood* and *Peasant Girl* (cat. 19 and cat. 20, front cover) date from the 1940s and are modeled by children standing on artificial grass against kitschy forest backdrops that resemble those once used in elementary school theater productions. In one image, Little Red Riding Hood gazes with an expression of horror at the wolf—played in turn by another child, in what looks more like a brown bear costume. In Galembo's companion piece *Peasant Girl*, a knowing adolescent looks directly at the viewer in feigned innocence from an identical ersatz forest setting.

ANNA GASKELL also draws her inspiration from fairytales.[61] Gaskell explains that her "images are from stories. Stories I've heard, stories I've been in, and stories I've read…. You might say I'm looking for the real in the fiction or vice versa."[62] Like the great fairy tales that serve as her source material, she delves into the nexus between innocence and perversity, and the girls who pose for her tableaux are on the cusp between childhood and puberty. (Interestingly, Gaskell was once employed as a photo editor for *Child* magazine, an experience that, she explains, inspired her to seek out young models for her work.) In each of the photographs in her series *A Short Story of Happenstance* (cat. 13), adolescent girls in a forest are engaged in childhood games such as leap frog, blind man's bluff, and tug-of-war. Dressed in virginal Victorian garb such as pinafores, lace-up shoes, petticoats, white nightgowns and stockings, these girls are oblivious to danger. There is a cinematic quality to Gaskell's photographs

and many could be mistaken for film stills. She acknowledges Alfred Hitchcock as an influence, particularly his movie *Rebecca* (based on Daphne du Maurier's popular gothic novel).

JANET CARDIFF AND GEORGE BURES MILLER are also influenced by the aesthetics of cinema, and create virtual worlds where the viewer becomes a voyeur or eavesdropper on narratives that are never completely resolved. Cardiff and Miller are interested in overheard conversations, titillating clues, and blurring the line between fact and fiction. *Film noir* and detective movies especially appeal to them, and they have gone so far as to build their own vintage theaters. *Paradise Institute*—a prize-winning entry made for the Canadian pavilion at the 2001 Venice Biennale—is a sixteen-seat miniature movie theater where the audience watches a film about strange happenings at a sinister medical clinic in the woods. The Canadian landscape frequently figures in their work. And Cardiff's first guided audio walk, a format that made her famous, was a tour through a forest. Their contribution to this exhibition, *Cabin Fever* (cat. 9), is set in a diorama resembling those found in old-fashioned natural history museums. The wooden cabinet contains a night scene set in a rustic house in a forest. The viewer dons headphones and witnesses what might be a murder. Enhancing the reality of the scene are the installation's lighting and an innovative and highly sophisticated binaural surround-sound system—which allows viewers to feel the sound of tires on gravel, slamming doors, and the harsh words that they hear.

The exploration of cinematic conventions and the creative use of sound also converge in DAVID CLAERBOUT's *Le Moment* (cat. 33), a video in which the viewer is led down a dark path and into the woods. The piece is something of a shaggy-dog story (even if it actually involves a cat), and with a Hitchcockian touch, Claerbout blends the sounds of footsteps and rustling leaves to create a ghostly forest setting. Although playful, the video is not by any means simply a joke. Claerbout's work thoughtfully isolates and draws our attention to many of the cinematic elements that have been regularly employed in horror genre filmmaking. And as anyone who is a fan of films like *The Texas Chainsaw Massacre*, *Night of the Living Dead*, or more recently *Blair Witch Project* will know, forests are conventionally a setting for dreadful events. Such viewers' expectations are very much Claerbout's subject. By remixing and manipulating music from films by David Lynch (a director who has used forest settings in his work to great effect) with sound from works by other famous filmmakers, Claerbout builds up tension and anticipation that he then abruptly deflates. In an interview with Hans Ulrich Obrist, Claerbout explains that he "amputates [those]

aspects of cinema, like expectation, drama [and] plot,... that could be called 'the global neurotics of cinema.'... And instead offers a proposal for a way of experiencing time which seems slower."[63] In *Le Moment*, Claerbout contrasts the distant way we usually experience film with our ordinary, everyday approach to seeing the world.

WIM WENDERS is both an internationally recognized film-maker and an accomplished photographer. With a film career that spans more than three decades, he is one of the greatest directors of his generation, and a restless traveler who normally scouts for his film locations himself. In the 1970s, when Wenders began to take pictures, it was with the idea of getting a sense of the light and landscape of a place before he began a film's principal photography. But by the early 1980s, he found he had begun to take photographs for their own sake. As a former art student, he acknowledges the influence of such painters as Caspar David Friedrich and Edward Hopper, and claims that a photograph by Walker Evans was the starting point for his 1976 film *Kings of the Road*. Wenders' photographs are—like many of his most popular movies such as *Paris*, *Texas* and *Buena Vista Social Club*—as much about the places where they were shot as the stories they tell. He writes, "Places have memories. They remember everything. It's engraved in stone. It's deeper than the deepest waters. Their memories are like sand dunes, wandering on and on. I guess that's why I take pictures of places: I don't want to take them for granted. I want to urge them not to forget us."[64] One place Wenders regards as special is just outside the city of Nara, Japan, where seven great shrines and temples stand, including the famous 8th-century Toshodaiji Temple. Wenders' photograph in this exhibition (cat. 14) was taken in the bamboo forest adjacent to the Toshodaiji Temple, which is populated by descendants of the ancient order's original herd of sacred deer.

Bamboo forests are as central to Asian identity as the Redwoods of California are to Americans. Bamboo, technically a grass, is symbolic of Zen enlightenment because it bends but does not break. The Yin and Yang lines found in the *I Ching* reflects its form, and bamboo is a traditional subject of paintings in East Asia as often as the nude is in the West.[65] YANG FUDONG's film *Seven Intellectuals in Bamboo Forest, Part 1* (cat. 12) is a cool, dreamy, meditative riff on the philosophical questions of existence. His camera follows seven young people as they wander the wilds of China's famous Yellow Mountain, Mount Huangshan. One of the nation's five sacred mountains, Huangshan is known for its gnarled pines, fantastic rock formations, and ghostly mist—all of which Yang has beautifully photographed. His black and white film, reminiscent of traditional Chinese brush and ink painting, is a contemporary take on a famous group of 3rd-century poets and artists known as the Seven Sages of the Bamboo Grove. As Yang has written:

The Seven Sages of the Bamboo Grove were a group of Chinese scholars and poets who fled the troubles accompanying the transition between China's Wei and Jin dynasties during the mid-third century. They assembled in a bamboo grove, where they forgot all of their worldly troubles, losing themselves in pure thought and discussion. This sort of retreat was typical of the Taoist-oriented ch'ing-t'an (pure conversation) movement, which advocated freedom of individual expression and hedonistic escape from extremely corrupt politics. Their ideal consisted of following their impulses and acting spontaneously, and being sensitive to the beauties of nature.[66]

Seven Intellectuals in Bamboo Forest, Part 1 is both nostalgic for the past and equally concerned with contemporary Chinese society. It is the first installment of an epic consisting of five films (three still in production), that will follow the story of seven young people whose ideals contrast with everyday reality. Yang's films include women, and he signals several rapid shifts of decades of turmoil and flux with clothing. His characters' costumes change from the styles of the revolutionary 1950s to those of the subsequent Cultural Revolution, and finally to those of contemporary corporate and consumer culture. As his characters wander a mountainside forest, they alternate conversation and soliloquies about love, life, death, and beauty over a haunting soundtrack. Yang says that his primary focus is on the spiritual level of his *Seven Intellectuals* and their hope of rediscovering "the Utopia that once existed at the bottom of the hearts of everyone."[67]

Practice

THE FINAL SECTION OF THE exhibition includes artists who propose real-life solutions to environmental problems or who employ scientific methodology in their work. It also includes documentation of art that is performance based, as well as the work of artists who were commissioned by the Nasher Museum to inaugurate its new home.

ALAN SONFIST is an artist and ecologically aware social activist, best known for his early project *Time Landscape* (cat. 17), a seminal environmental artwork, first proposed to New York City in 1965. Sited on a busy street in a primarily commercial zone of Manhattan, just north of Soho, *Time Landscape* is a replanting, on a 9000 square-foot plot, of indigenous trees and plants that once existed in Manhattan as primal forest. Sonfist's visionary idea was so unusual at the time he initially made his proposal, it took over ten years of negotiation with city officials and others to get permission and the funding to begin work. Eventually, he gained the support of important figures in both government and the art world, and the project was completed in 1978. *Time Landscape* has served as a model for public art and for many environmentally-based artworks, and even affected New York City policies concerning public landscaping projects that have no particular or professed artistic aim. In the mid-1960s, however, public art and the ecology movement were both in their infancy, and those involved in the city's parks and other landscaping projects generally thought indigenous species were too common to bother with—they preferred to use European trees and plants. In more recent years, the phenomenal success of *Time Landscape* has changed that opinion, and in 1998 Sonfist's work was awarded landmark status by the Parks Commissioner.

Sonfist is often compared to artists such as Robert Smithson and Michael Heizer who became known for monumental Earthworks in the 1960s. The difference, however, was that Sonfist was determined to bring nature back into the fabric of urban life, rather than take "art out of the city and into the surrounding landscape in a way that jeopardizes the natural subject."[68] Sonfist grew up in the South Bronx and played in the wooded areas bordering the mean streets of his neighborhood as a child. He credits his life-long dedication to the preservation of nature to that early experience, and to his dismay that his beloved urban woodland was later paved over and rapidly became an urban wasteland. Sonfist is an avid local historian and archaeologist, and in preparation for *Time Landscape* he "searched through old Dutch records of lumber supplies and read accounts by the first Dutch settlers of walks to their favorite streams."[69] As a former fellow at the Massachusetts Institute of Technology, Sonfist also believes in the importance of connecting art with science. He keeps abreast of recent developments in environmental studies and frequently collaborates with botanists and other specialists.

Sonfist is represented in the exhibition by documents and photographs of *Time Landscape* and by a more recent project from 2003, *The Monument of the Lost Falcon* (cat. 18). Here, he chose to symbolically reintroduce a lost native species of a different kind—the falcon. And this time his site was a forest in the Sauerland region of Germany, where the local government invited him to create a work on the publicly accessible hereditary estate of the princely family that had once ruled the area. Sonfist constructed a three-foot-high earthen enclosure outlining the shape of a falcon (at one time the family had kept falcons), and planted larch trees—indigenous to the area—on top of it. The falcon's silhouette or shadow, as Sonfist calls it, is surrounded by a gravel path and so large that its shape is only discernible from the air. Working with a team of botanists and other scientists, he planted 350 different seedlings within the structure—gathered from as far afield as China and the United States—to create a forest of memory consisting of trees and plants once common to the zone but which no longer grow there naturally.

CARSTEN HÖLLER is a trained scientist who holds a doctorate in phytopathology (the study of plant diseases), yet questions the rationality of science, and talks of creating "Laboratories of Doubt as a remedy for certainty."[70] His work can be mischievous (or at times, even manipulative). For example, one of Höller's interactive experiments in visual disorientation involved the invention of a 'confusion machine' that included a pair of spectacles which allowed the viewer to see upside down an entire room of giant mushrooms that hung from the ceiling. Höller's investigations have ranged widely, and include ornithology, entomology and how insects communicate by smell, Icelandic reindeer rituals, the hallucinogenic mushroom known as *Soma* used by the Vedic people, and even the origin of Santa Claus. Höller has always been particularly interested in the human longing for happiness and the search for love. Typically, he takes a contrarian's view that is rooted in scientific disinterest, and has said that "happiness is not a goal in itself, but serves other things. This utilitarian side of it is scary, since we don't know what exactly it is good for."[71]

Höller's video *The LoverFinch* (cat. 4) documents how he bred and trained seven male and three female bullfinches to sing specific songs that trigger human emotions. They include *Indian Summer* by Joe Dassin (the song Höller remembers first falling in love to), the title melody from the movie

Gremlins, and the Italian partisan song *Ciao Bella*. The video shows the training method and presents the birds as surrogate humans, each with its own individual sense of humor. One underlying question is what emotions do the birds feel while singing—and closely related, how do their emotions compare to those of humans? The video was inspired by a legendary 18th-century love story about a German baron, Johan Ferdinand Adam von Pernau, who lived on a wooded estate called Rosenau, near the southern German town of Coburg. The baron became infatuated with a girl from the local village, but she consistently rejected his advances. In frustration, he ordered all the bullfinches in the nearby forest to be captured and confined in the cellar of his castle. The baron then spent months teaching the birds a love song he had once sung under the young woman's window, and he then released them into a forest where she regularly walked. One day, when she realized that all the birds were singing for her, she finally fell in love with the baron, as he had hoped. Though more than two centuries have passed, ornithologists have discovered that traces of the love song, handed down through generations of bullfinches, are still heard on the Rosenau estate.

RODNEY GRAHAM is a versatile artist who makes films, videos, photographs, installations, and sculpture. He is a native of Canada (where his father once ran a logging camp), a songwriter and composer,[72] and a member of a group of internationally known conceptual artists working in Vancouver. The contrast between nature and urban life figures regularly in Graham's work and is a theme that he often pursues with a wry sense of humor. In an early work, entitled *Edge of Wood*, he theatrically lit a forest ravine and invited his audience to come observe the spectacle. Graham is best known for a series of photographs (taken over more than two decades) of individual trees, most leafless, and exhibited upside down.[73] The black and white print shown here (cat. 16) is reminiscent of 19th-century documentary photographs of the American wilderness by Carleton Watkins, Timothy O'Sullivan and William Henry Jackson.

Graham began this series in 1979 after building a *camera obscura* (a device many art historians suggest played a crucial role in the development of landscape painting). Graham explains that his project "started out as part of an interest I had in the problem of the representation of nature. I made an actual *camera obscura* for the purpose of installing it in a landscape so that an inverted image of a tree would be realized on a screen inside it…. I was interested in the idea of an inverted image of a tree as a kind of symbolic image."[74] A bare tree can serve as a symbol of mortality and a solitary tree can be the sad reminder of a forest that has been clearcut. Graham soon abandoned the cumbersome walk-in cam-

era and began a series of tree portraits. In a reversal of the old canard about "not seeing the forest for the trees," he says, "I was interested in this idea of isolated trees, which is something that is hard to find here in British Columbia, where you've got forests of trees. I was thinking of the category of portraiture, and all of that 19th-century photography of trees—very straightforward documents…. I was particularly interested in it as an iconic image, something you would see in a textbook illustrating the idea of the inversion of an image in general, showing the mechanism of the optics of the eye. You often see a tree being used, so I was thinking of this kind of diagrammatic, archetypal image."[75]

JOSEPH BARTSCHERER's methodology resembles that of a 19th-century naturalist who documents and catalogues types, capturing very specific information with the camera. His images are often very beautiful, but should not be mistaken for romantic visions of nature. He dispassionately records what is there, much in the spirit of August Sander's photographs documenting the lives of workers in Germany's Weimar Republic. Judith Tannenbaum writes:

> As a photographer, Bartscherer strives to heighten a viewer's awareness of the myriad ordinary incidents that take place daily in our environment (how light falls on tree bark, how a plant grows), as well as monumental events of history, such as the formation of rivers and mountains or the building of cities. He implies that both types of occurrences impact upon us profoundly, although humans may not be present in the pictures.[76]

Nancy Princenthal calls Bartscherer "a conceptual artist with the intentions of a social theorist."[77] In *Canal*, for instance (a project commissioned by London's Tate Gallery), Bartscherer tracks the man-made artery that carried the raw materials for the Industrial Revolution from Leeds to Liverpool, and in Bartscherer's *Pioneering Mattawa* series, he documented the agricultural development of a formerly untouched region of Washington state. *Pond* (cat. 10), a large-scale four-panel photograph, is a highly detailed image that records the inexhaustible variation in the color and shape of fallen leaves as they move through water. This magnificent work is part of a series entitled *Forest*, begun in 1999 and shot in the old-growth Great Mountain Forest of northwestern Connecticut. One version of *Pond* was commissioned by the Institute of Contemporary Art at the University of Pennsylvania, which planned to hang four monumental banners of it in Philadelphia's 30th Street train station. Unfortunately this public artwork met with the same fate as many real forests when it was pre-empted by powerful advertisers who claimed the formerly unused space as their own.

PAUL ETIENNE LINCOLN is, in spirit, very much a throw-back to the eccentric inventors of Victorian England. Sometimes called an alchemist (though mad scientist might be more like it), he is also a naturalist and botanist who is deeply concerned with issues of ecology and conservation. Lincoln's obsessive methodology and fastidious attention to detail, however absurd, consistently charm us, and particularly when his work sets in motion some loopy, Rube Goldbergesque chain of events. His objects are all built by hand in his Brooklyn workshop (where he also repairs accordions), and his art-making materials have included such effluvia of high school chemistry experiments as Leyden jars, electrostatic generators, glass stills and beakers, as well as ticker tape and milking machines, flare guns, orange peelers, gin bottles, and feather dusters.

Lincoln is resourceful and dogged in his research, and delights in obscure facts and information, rescuing lost industrial sounds, bird songs, and old opera recordings. These frequently find their way into his archaic or anachronistic machines and bewildering objects, many of which he displays in vitrines. An example of one of Lincoln's modern-day *wunderkammers* is included in the exhibition, and it contains artifacts and ephemera from his performance *The Purification of Fagus Sylvatica Var Pendula* (cat. 32), a work commissioned by New York's Queens Museum for *Crossing the Line* (an exhibition curated by Valerie Smith in 2001). For his elaborate performance, Lincoln dressed in a full-length robe made with beech tree leaves and beechnut casings, and performed a long ritual he had created dedicated to the weeping beech tree. He used a still of his own invention to make creosote (a substance used as an anesthetic, antiseptic, and a preservative for mummies) from the wood of a weeping beech. According to some historians, the first weeping European beech planted in America was grown from a shoot brought here in the mid-19th century by a Quaker nurseryman, Samuel Parsons, who had taken it from a tree that grew on an estate in Beersal, Belgium. Parsons' original weeping beech died in 1998, but its stump remains, surrounded by seven surviving progeny or "daughters" in the wooded Weeping Beech Tree Park in Queens. The vapor from Lincoln's chemical process, captured in hollow tubing, spells out the names of the Pleiades—the seven daughters of Pleione and Atlas—also corresponding to the seven surviving weeping beech trees.

JOAN JONAS was one of the most important cross-disciplinary artists to emerge in the early 1970s and is known for her work integrating dance, theater, performance art, film, video, body art, installation, sculpture, and drawing. As a child, on summer vacations with her family, she spent many hours in the woods in New Hampshire, and forest images frequently recur in her work. Jonas says that "she has always loved the forest and thinks of it like a house that is safe and familiar."[78] Her 2004 video *Waltz* (cat. 27) documents a performance that was shot in and around the forest near her summer house in Cape Breton, Nova Scotia. The area is popular with artists, including Fluxus pioneer Geoffrey Hendricks and Sur Rodney Sur, both of whom appear in Jonas' video as mysterious voyeurs. The soundtrack is Jonas' arrangement of *The Hundred Year Waltz*, a composition based on traditional Irish and Scottish music written by Otis A. Thomas, another Cape Breton neighbor who is also a violinmaker. Some of the images in *Waltz* are based on the masks, costumes, and choreography Jonas developed when working with Robert Ashley on his 2003 opera *Celestial Excursions*. Other imagery, such as a death mask and red and black flags, is loosely based on her thoughts about Francisco de Goya's etching series, the *Disasters of War*. Jonas' primary sources of inspiration for the creation of *Waltz*, however, are the Dutch tradition of the portable children's theater, improvised amateur theater performed in European gardens, and French revolutionary outdoor theater.

WOLFGANG STAEHLE, the pioneering cyber artist who founded the renowned artists' Internet network *The Thing* (http://bbs.thing.net), has been making work in real-time since 1995. The Nasher Museum has commissioned him to create a new work using the forests around Duke especially for this exhibition. Staehle was among the first to use digital technology to project actual images into art spaces from the outside world via the Internet. Unlike film and video, Staehle's projections are continuous, and in theory might be broadcast forever (or as long as the camera is in place and working). And they do not necessarily require the presence of a viewer. Staehle's work addresses the nature of time, how it is perceived in our culture, and how that notion has changed with new technology. In connection with a work Staehle did in 2001, he quoted Martin Heidegger's prescient 1935 *Introduction to Metaphysics*, in which Heidegger poses an essential problem of post-industrial existence:

At a time when the farthermost corner of the globe has been conquered by technology and opened to economic exploitation; when any incident whatever, regardless of where or when it occurs, can be communicated to the world at any desired speed…when time has ceased to be anything other than velocity, instantaneousness, and simultaneity, and time as history has vanished from the lives of all people…a question still haunts us like a specter: What for? Whither? And what then?"[79]

The ideas of other German philosophers, including Immanuel Kant's theories of aesthetics and the Romanticism of Friedrich Schiller, have also been important to Staehle's thought processes.

Unlike works by many new media artists, Staehle's work is comparatively low tech, and much more about ideas and images than the newest bells and whistles. He creates projects with a straightforward simplicity: after selecting a subject, he mounts a digital camera, or cameras, which point at the subject and automatically take photographs every few seconds. The pictures are then encoded as JPEGS and sent from a server over the Internet to a computer in the exhibition space, where the images appear as projections. Though Staehle's photographs arrive every few seconds, the effect is more a sequence or a tableau than that of a live broadcast. It is as though Staehle was using technology to slow down the bombardment of images made possible by the Internet. A number of important artists have experimented with live-feed techniques since the 1960s, including Dan Graham, Yoko Ono, Bruce Nauman, and Andy Warhol, and Staehle's work may be seen as a continuation of that tradition. In fact, his 1993 *Empire 24/7*, a round-the-clock view of the Empire State Building, is a direct reference to Warhol's famous eight-hour film *Empire* (1964).

Staehle's work blends the aesthetics of painting with an intentional Warholian postcard banality, although real-life events can intervene to puncture the calm. For instance, the September 11 attacks on the World Trade Center were inadvertently captured in an untitled work (cat. 28) that was supposed to be simply a panorama of lower Manhattan shot from Brooklyn. Staehle chooses his subjects with great care, and he possesses a gift for visual composition, so the results can be breathtaking—as is the case with his recent vista of the Hudson River Valley and Niagara Falls. These images are more like 19th-century landscape paintings than the work typical of new media practitioners; it is almost as if a Frederic Church painting was the subject of video security surveillance. Even the aforementioned work from 2001 captured the terrible beauty of a horrific event.

The Nasher Museum has also commissioned North Carolina artist PATRICK DOUGHERTY to create a special outdoor "stickwork" to celebrate its inauguration. Dougherty's materials, which come exclusively from the woods near the museum, are used to build structures connecting the museum to the natural environment that surrounds it. And Dougherty weaves truckloads of tree saplings and twigs into elaborate architectural structures that recall the twisted forms of cocoons, nests, haystacks, and huts. He first learned about primitive building techniques while constructing his own home and soon after began to use these processes in his art. Since 1982, when his first stickwork was shown in Raleigh, he has built over 100 such works throughout the world (cat. 5). Dougherty's technique is ingenious. His sculptures are very complex yet he uses no hardware to support the forms he creates. Instead he twists the found twigs into elaborate woven structures that stand on their own. Dougherty has a profound love of nature and has combined this with his considerable building skills. He says:

> My affinity for trees as a material seems to come from a childhood spent wandering the forest around Southern Pines, North Carolina…a place with thick underbrush and many intersecting lines evident in the bare winter branches of trees. When I turned to sculpture as an adult, I was drawn to sticks as a plentiful and renewable resource. I realized that saplings have an inherent method of joining…that is, sticks entangle easily. This snagging property is the key to working material into a variety of large forms.[80]

The work of the thirty internationally recognized artists exhibited here has been divided into the three categories of politics, poetics, and practice discussed above, but it is essential to remember that these groupings were conceived simply to organize a very wide range of work dealing with the subject of the forest. To make such a complex exhibition more comprehensible to a diverse audience, it was necessary to devise a credible structure within which to examine the works included. That said, artists are loath to be categorized and their works almost always resist this kind of paradigm. The designations given should not be regarded as anything more than a starting point, especially since all the artworks in the exhibition address issues that fall into all three categories. One could make a convincing case that almost every work shown here is political to a greater or lesser degree. The social upheavals of the 1960s and a growing awareness of possible environmental catastrophe form the backdrop to these works, even those that were made very recently. Likewise, the broad term poetics also informs nearly all the work included here, even when an artist made it for a direct political purpose. Artists have always absorbed the ideas, sights, and sounds of the culture of which they are a part. And a process of osmosis and the confluence of current events with myth, legend, religion, literature, music, film, and other human endeavors is part of what inspires them with new ideas that are both compelling and challenging.

1. Wangari Maathai, "The Cracked Mirror," *Resurgence* 227 (November 11, 2004), http://www.resurgence.org/contributors.

2. Kathryn A. Fahl, ed. *Forest History Museums of the World* (Santa Cruz: Forest History Society, 1983). This publication lists forest museums around the world.

3. Robert Rosenblum, "The Withering Green Belt: Aspects of Landscape and Culture in the Twentieth Century," in *Denatured Visions, Landscape and Culture in Twentieth Century Art*, eds. Stuart Wrede and William Howard Adams (New York: Museum of Modern Art, Abrams, 1991), 39.

4. John Beardsley, "Landscape After Modernism," in *Denatured Visions, Landscape and Culture in Twentieth Century Art*, eds. Stuart Wrede and William Howard Adams (New York: Museum of Modern Art, Abrams, 1991), 110.

5. *Silent Spring* was first published as a series in the *New Yorker* in 1962. Rachel Carson, a former marine biologist with the U.S. Fish and Wildlife Service, is credited with beginning the ecology movement, and her widely influential book about the hazards of DDT pesticide led to a government ban on its use.

6. "Conversation with Jerry Mander," in Derrick Jensen, ed. *Listening to the Land: Conversations About Nature, Culture, and Eros*, 2nd ed. (San Francisco: Sierra Club Books, 2002), 99.

7. http://www.ran.org. Rainforest Action Network.

8. Ibid.

9. Although it received little attention at the time, it has been acknowledged that the 2004 tsunami disaster was exacerbated because mangrove forests were cut down to accommodate tourist resorts and the coral reefs were diminished because of pollution. In the past both would have served as seawalls to break the full impact of the waves. See, for example, G. Venkataramani, "Mangrove Forest Absorbs the Brunt of the Tsunami," *The Hindu*, December 27, 2004, http://www.truthout.org/docs_04/122904V.shtml. Also see Geoffrey Lean, "God and Mangroves," *The Independent*, January 9, 2005, http://www.truthout.org/docs_05/011005G.shtml.

10. http://www.rainforestfoundation.org. Rainforest Foundation. All such figures are controversial, and wholly disinterested sources of information are difficult to come by.

11. The *New Yorker* recently published at three-part article by Elizabeth Kolbert that provides a cogent introduction to the environmental sciences, their history, and the economics and politics of environmental policy. Elizabeth Kolbert, "The Climate of Man Parts I-III," *New Yorker*, April 25, May 2, 9, 2005, 56–71, 64–73, 52–63. Discussions of 19th-century scientific research appear in "The Climate of Man Part I," 66.

12. Rob Jackson, *The Earth Remains Forever* (Austin: University of Texas Press, 2002), 59. Jackson's book is a balanced and readable survey of contemporary environmental issues. He points out on page 59, "Of the 265 billion tons of carbon generated in fossil fuel burning and other activities since 1750, half came after 1975."

13. Kolbert, "The Climate of Man Part I," 56.

14. Larry Rohter, "U.S. Waters Down Global Commitment to Curb Greenhouse Gases," *New York Times*, December 19, 2004. Undersecretary of State for Global Affairs Paula Dobriansky led the U.S. delegation to a 2004 conference on climate change held in Buenos Aires. She stated, "Science tells us that we cannot say with any certainty what constitutes a dangerous level of warming, and therefore what level must be avoided."

15. Sir John Houghton, "Global Warming Is Now a Weapon of Mass Destruction," *The Guardian*, July 28, 2003, http://politics.guardian.co.uk/green/comment.

16. Andrew C. Revkin, "Eskimos Seek to Recast Global Warming as a Human Rights Issue," *New York Times*, December 15, 2004.

17. Jackson, *The Earth Remains Forever*. Jackson continues, "We generate a quarter of the world's fossil fuel emissions with less than five percent of its population." xvi.

18. David Lowenthal, ed., *George Perkins Marsh, Man and Nature* (Cambridge: Harvard University Press, 1965), 119.

19. Jared Diamond, *Collapse: How Societies Choose to Fail or Succeed* (New York: Viking, 2004), 79–119.

20. J. Donald Hughes, *Pan's Travail: Environmental Problems of the Ancient Greeks and Romans* (Baltimore: Johns Hopkins University Press, 1994), 68. According to Hughes, the Roman government gave vast tracts of forest to the privileged classes for development, and the depleted land was progressively abandoned from the 3rd century AD on, causing food shortages and unrest. On the other hand, though deforestation was part of their undoing, it has recently been discovered that the Romans brought the first elm to Britain. See "British Tree Brought by Romans," *Archaeology*, January/February 2005, 13.

21. Hughes, *Pan's Travail*, 128.

22. Ibid., 70.

23. The Duke Forest began in the 1930s, a decade after the university bought up farmland that had been abandoned since the end of the Civil War. Cotton and tobacco had depleted the soil around Durham, making it unsuitable for agriculture, and the freed slaves who migrated to the cities were no longer the source of free labor. Duke professor Daniel D. Richter has extensively studied the consequences of these soil changes in the southeast and their lessons for land management. In 1931, the first director of the Duke Forest, Clarence F. Korstian, established the property as an outdoor laboratory for research on timber growth and management. Thousands of trees were planted, and the rest of the land was left to regenerate itself. In 1938 Korstian founded the forestry school at Duke, and the university is still active today in fields closely allied with forestry. The Nicholas School of the Environment and Earth Sciences uses the Duke Forest for experiments, while Duke's Primate Center studies and protects lemurs and other animals that are nearly extinct in their native Madagascar. Because of deforestation, the island is one of today's most endangered biodiversity hotspots. http://www.duke.edu/forest, http://www.nicholas.duke.edu, http://www.primatecenter.duke.edu.

24. John F. Richards, *The Unending Frontier: Environmental History in the Early Modern World* (Berkeley: University of California Press, 2003). This book covering the period 1500–1800 is among the first scholarly monographs on the subject.

25. Jackson, *The Earth Remains Forever*, xvii.

26. Simon Schama, *Landscape and Memory* (New York: Knopf, 1995), 239.

27. Ryan Fryar, "Joseph Beuys: Making Himself Art," http://www.tc.umn.frya0002/Art/20History/20Essays/Beuys/beuys.html.

28. Schama, *Landscape and Memory*, 117. This passion for nature tainted by the Nazis was so pervasive that even Walter Benjamin, a casualty of the regime, was in his early years a member of the *Wandervogel*, clubs of youths who celebrated their Germanic origins in the forest.

29. Fryar, "Joseph Beuys."

30. Sir James Frazer, *The Golden Bough: A Study in Magic and Religion.* Frazer's epic work, first published in 1890, occupied the author for approximately 25 years. Initially a two-volume study, his survey of the world's ancient customs, superstitions, magic, and myth grew to 13 volumes in its enlarged and revised 3rd edition published between 1911 and 1913. It has appeared in multiple editions over the years.

31. Margaret Sundell, "Lothar Baumgarten, Whitney Museum of American Art: Ambivalence Infuses The Origin of the Night," *Artforum*, December 2003, 149.

32. Unpublished artist's statement.

33. Ibid.

34. Although the destruction of tropical rainforests is a lighting rod for ecological activists, it is interesting to note that "deforestation rates in the United States are twice as high, about one percent annually." Jackson, *The Earth Remains Forever*, 44.

35. Suzanne Muchnic, "Into the Mind of the Shaman," *Los Angeles Times*, August 3, 2003.

36. Vega's version of Dante's Canto reads:

> When I had journeyed half our life's way
> I found myself within a dark jungle
> for I had lost the path that does not stray.
>
> Ah, it is hard to speak of what it was,
> That savage jungle dense and difficult,
> Which even in recall renews my fear:
>
> So bitter-death is hardly more severe!
> But to retell the good I discovered there,
> I'll also tell of the other things I saw.

37. According to Vega, Pinelo finally identified the Garden of Eden as a perfect circle, 510 miles in diameter, in the middle of South America, from which the four rivers cited in the Bible flowed. The idea of South America as a lost paradise was not new. It led the 16th-century conquistadors to embark on the futile search for the gold of El Dorado. And Sir Walter Raleigh literally lost his head because he failed to find it. It is interesting to note that although Pinelo's quest was theological, he anticipated the discipline of natural history by compiling the most exhaustive inventory of plant and animal species of South America of the time.

38. Unpublished artist's statement.

39. Michael Workman, "Iñigo Manglano-Ovalle: Anatomy of a Black Hole," *Flash Art*, January/February 2004, 79.

40. An-My Lê, "Small Wars," *Cabinet Magazine*, Spring 2001, 34.

41. Unpublished artist's statement.

42. Ibid.

43. Marching trees appear in the 14th-century Welsh poem *Book of Taliesin*, in Shakespeare's *Macbeth*, and more recently in J.R.R. Tolkien's *Lord of the Rings* trilogy.

44. Of course, others might also make this claim. The act of disguising oneself during warfare appears frequently in history and literature.

45. Unpublished artist's statement.

46. Ibid.

47. Telephone conversation with the author, February 12, 2005.

48. George Alexander, "Post Natural Nature: Rosemary Laing," *Artlink*, December 2002, 20.

49. Dhlomo, Bongi, "Zwelethu Mthethwa Talks About His Photographs," in *Liberated Voices: Contemporary Art from South Africa*, ed. Frank Herreman (New York: Museum for African Art, 1999), 71.

50. Alan Davidson, *The Oxford Companion to Food* (Oxford: Oxford University Press, 1999), 867–884.

51. Troy Selvaratnam, "The Starling Variations," *Parkett* 67 (2001), 6.

52. Unpublished email from artist to author, February 25, 2005.

53. For example, the 19th-century Romantic poets Wordsworth, Shelley, Keats, and Byron took a particular delight in nature. Much of the action in Shakespeare's *As You Like It* and *A Midsummer Night's Dream* is set in the woods. And Euripides' *Bacchae*, set in the groves around Thebes, tells us much of what we know about the cult of Dionysius. Forests are the setting for scenes in operas as varied as Mozart's *Magic Flute*, Donizetti's *Lucia di Lammermoor*, Verdi's *Il Trovatore*, and Wagner's *Siegfried*.

54. This said, it may be true that the more a culture believes it has tamed nature (a fallacy, of course), the more inclined it is to cherish rather than fear the wilderness. In the United States, it could be argued that only well after the European settlement of the continent did a literature celebrating nature take root with writers such as James Fenimore Cooper, Washington Irving, and Henry David Thoreau. It was only then that landscape paintings of the great outdoors became possible, and such painters as Thomas Cole, Frederic Church, Asher B. Durand, and Sanford Gifford began rendering nature in idealized terms.

55. If we look beyond forests proper to settings in nature more generally such as mountains, caves, wilderness, and various imaginary Eden-like gardens, we find the Buddha's story closely paralleled by those of Moses, Jesus, John the Baptist, Mary Magdalene, St. Jerome, and St. Francis of Assisi, among others.

56. Baron/Boisante Editions, "Jennifer Bolande's *Forest Spirits*, Green Men and Monsters from the Id," press release, April 4, 1997.

57. Anne A. Simpkinson, "Something About Mary," http://www.beliefnet.com. According to Johan G. Roten, director of the Marian Library at the University of Dayton, visions of the Virgin are at an all time high, and he estimates that there are half a dozen reports of sightings each week (though he concedes that not all of them are authentic). Ibid.

58. D.L. Ashliman, "Folktexts: A Library of Folktales, Folklore, Fairy Tales, and Mythology," www.pitt.edu/dash/folktexts.html.

59. Kiki Smith and Helaine Posner, *Kiki Smith: Telling Tales* (New York: International Center of Photography, 2001), 12.

60. Phyllis Galembo, *Dressed for Thrills: 100 Years of Halloween Costumes and Masquerade* (New York: Museum at the Fashion Institute of Technology, 2002), 18.

61. Gaskell acknowledges such influences as the tales of the Grimm brothers, Charles Perrault, Hans Christian Andersen, E.T.A. Hoffman, Lewis Carroll's *Alice's Adventures in Wonderland*, the story of the *Pied Piper of Hamlin*, Mary Shelley's *Frankenstein*, and the ghost stories of Henry James and Edgar Allan Poe.

62. "Make/Believe, An Interview with Anna Gaskell," in Massimiliano Gioni and Israel Rosenfield, *Anna Gaskell: At Sixes and Sevens* (Paris: Yvon Lambert, 2004), 10–11.

63. Hans Ulrich Obrist, "Interview with David Claerbout," in *Point of View: A Contemporary Anthology of the Moving Image* (New York: New Museum of Contemporary Art, 2004). Boxed set of eleven DVDs by the following artists: Francis Alys, David Claerbout, Douglas Gordon, Gary Hill, Pierre Huyghe, Joan Jonas, Isaac Julien, William Kentridge, Paul McCarthy, Pipilotti Rist and Anri Sala.

64. Wim Wenders, *Pictures from the Surface of the Earth: Photographs by Wim Wenders* (Munich: Schirmer, 2003), 25.

65. Bamboo is used for architecture, household utensils, musical instruments and food. It is also important in preserving riverbanks and preventing erosion. However, because of development, Asia's bamboo forests are as endangered as any in the world. The panda is nearly extinct because bamboo, its primary food source, is diminishing.

66. Yang Fudong, "A Thousand Words: Yang Fudong Talks About the Seven Intellectuals," *Artforum*, September 2003, 182–183.

67. Yuko Hasegawa, "Yang Fudong, Beyond Reality," *Flash Art*, March/April 2005, 102-107.

68. John K. Grande, *Art Nature Dialogues: Interviews with Environmental Artists* (Albany: State University of New York Press, 2004), 66.

69. Robert Rosenblum and Wolfgang Becker, *Nature, The End of Art: Environmental Landscapes by Alan Sonfist* (Florence: Gli Oli, 2004), 23.

70. Hans Ulrich Obrist and Barbara Vanderlinden, *Laboratorium* (Antwerp: Provincial Museum voor Fotographie, 2001), 55–60.

71. Jens Hoffman, "Interview with Carsten Höller: The Synchro System and You," *Flash Art*, May/June 2001, 133.

72. The lyrics to one of Graham's songs include the following verse:

> Who does not love a tree?
> I planted one, I planted three.
> Two for you and one for me:
> botanical anomaly.

73. The idea of upside down art is not new. Kandinsky claimed that the spark for his abstract art was seeing an accidentally overturned canvas.

74. Barry Schwabsky, "Inverted Trees and the Dream of a Book: An Interview with Rodney Graham," *Art on Paper*, September/October 2000, 65.

75. Ibid., 67. Graham admits in this interview that he thought about the famous diagram of a tree in Saussure's *Course in General Linguistics* illustrating the signifier and the signified.

76. Judith Tannenbaum, *Joseph Bartscherer: Forest* (Philadelphia: Institute of Contemporary Art, University of Pennsylvania, 2000), 3.

77. Nancy Princenthal, "Joseph Bartscherer at Marian Goodman Gallery," *Art in America*, November 1995, 177.

78. Telephone conversation with the author, February 20, 2005.

79. Postmasters, "Wolfgang Staehle at Postmasters," press release, September 9, 2001.

80. Grande, *Art Nature Dialogues*, 16.

CAT. 1
JENNIFER BOLANDE
Forest Spirits, 1997
5 of 6 Iris prints from a suite of 16
Watercolor ink on Arches paper
20 x 16 in. each

Courtesy of the artist and Alexander
and Bonin, New York, NY
Photo © Jennifer Bolande

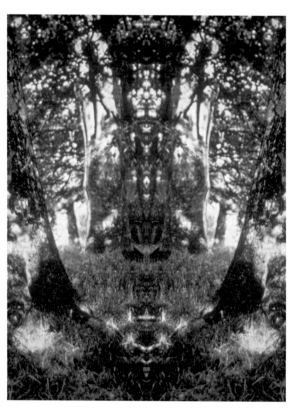

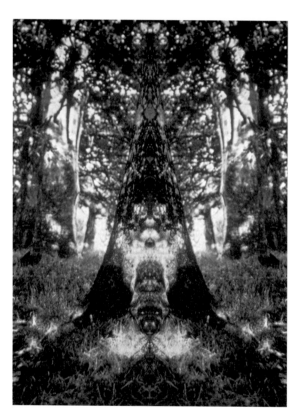

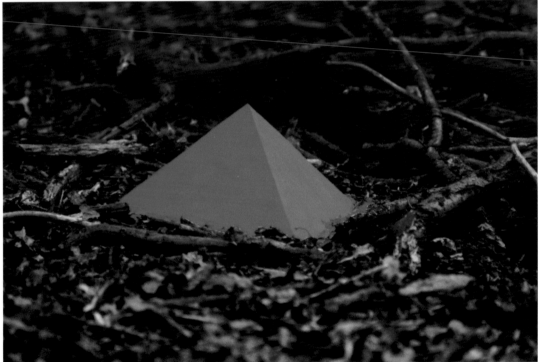

CAT. 2
LOTHAR BAUMGARTEN
Der Ursprung der Nacht (Amazonas-
Kosmos) [The Origin of the Night
(Cosmos of the Amazon)], 1973–1978
Color film transferred to DVD
98 minutes

Courtesy of the artist and
Marian Goodman Gallery, New York, NY
Photo © Lothar Baumgarten

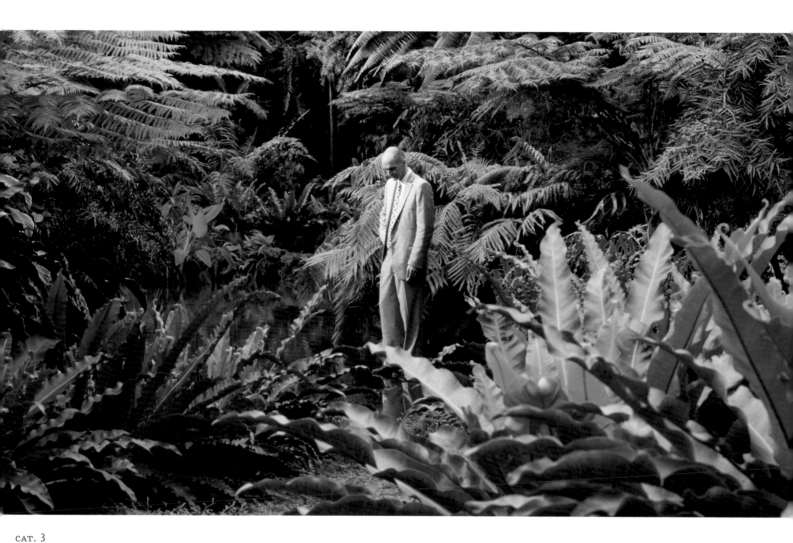

CAT. 3

IÑIGO MANGLANO-OVALLE

Oppenheimer, 2003

DVD video projection

3 minutes

Courtesy of the artist and Max Protetch
Gallery, New York, NY
Photo, video still © Iñigo Manglano-Ovalle

CAT. 4
CARSTEN HÖLLER
Loverfinch, 1995
DVD
13 minutes, 23 seconds

Courtesy of the artist and
Casey Kaplan, New York, NY
Photo, video stills © Carsten Höller

Searching to conquer the heart of his
beloved, the baron took all the young
bullfinches living on Rosenau Estate
out of their nests. He brought them
to his castle, where he taught them
the love song which he also used to
sing under the window of the girl.

Cherchant à conquérir le coeur de sa
bien-aimée, le baron récupéra de leur
nid tous les jeunes bouvreuils du do-
maine de Rosenau. Il les apporta à son
château où il leur apprit la sérénade
qu'il chantait sous la fenêtre de la
jeune fille.

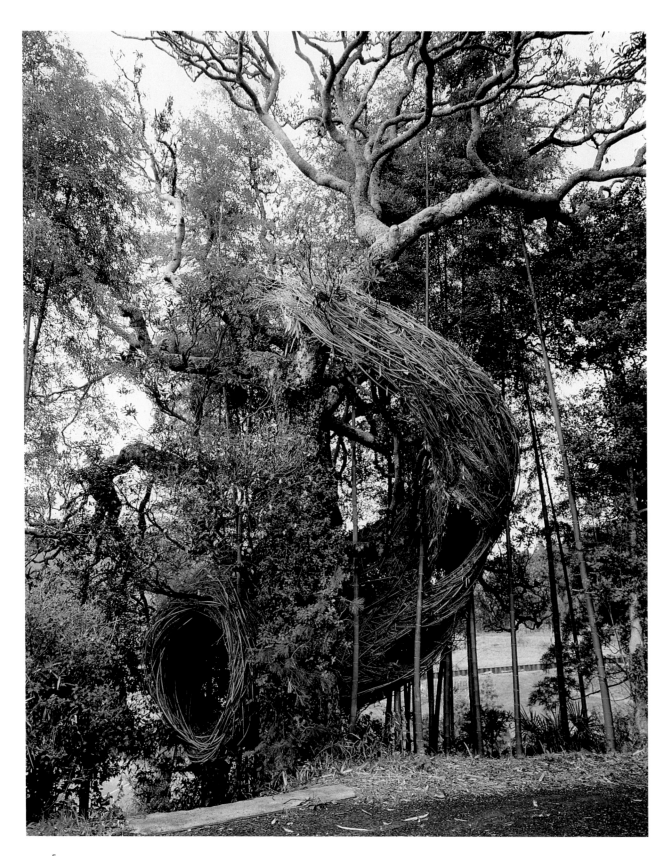

CAT. 5

PATRICK DOUGHERTY

Holy Rope, 1992 (not exhibited)
Rinjyo-In Temple, Japan
Reeds and bamboo
Height 25 feet
Courtesy of the artist, Chapel Hill, NC

Photo © Patrick Dougherty

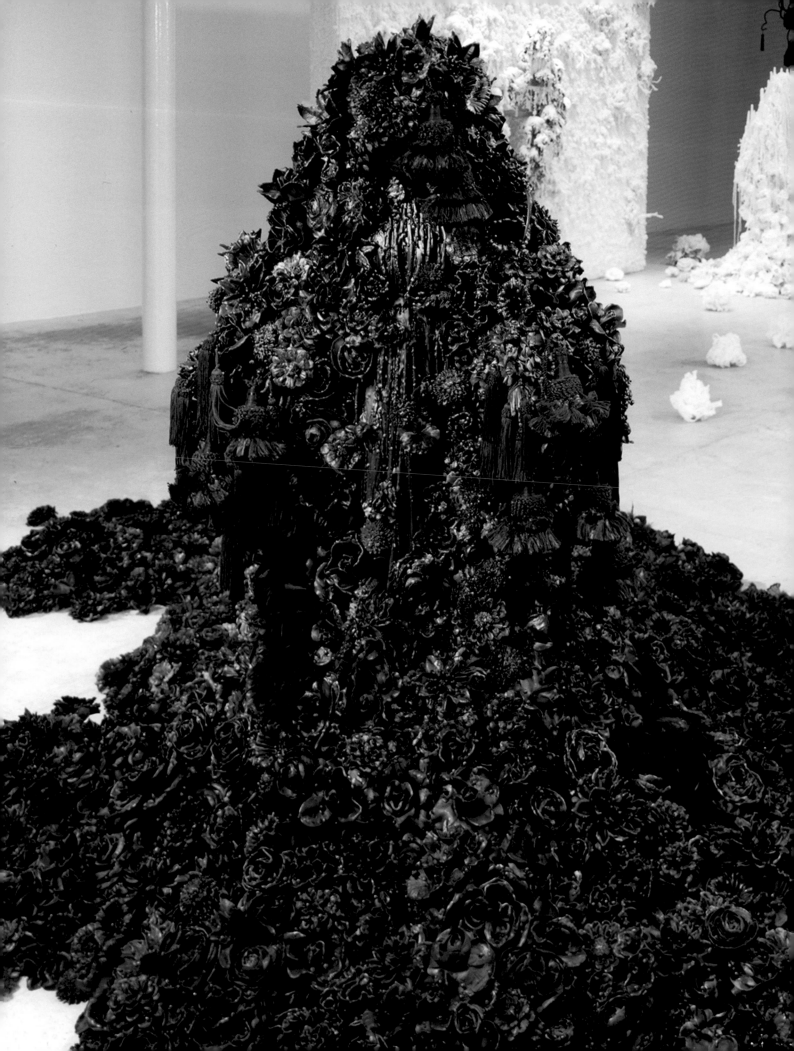

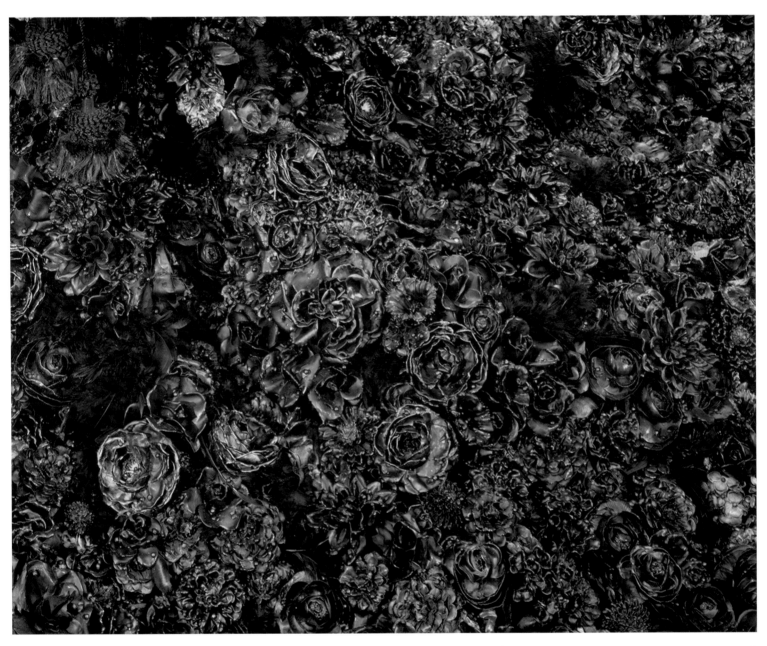

CAT. 6

PETAH COYNE
Paris Blue, 2002–2003
Mixed media
51 x 132 x 58 in.

Courtesy of the artist and Galerie Lelong,
New York, NY
Lent by the Joslyn Art Museum, Omaha,
NE. Purchased with funds provided by
Richard and Mary Holland.
Photo © Petah Coyne

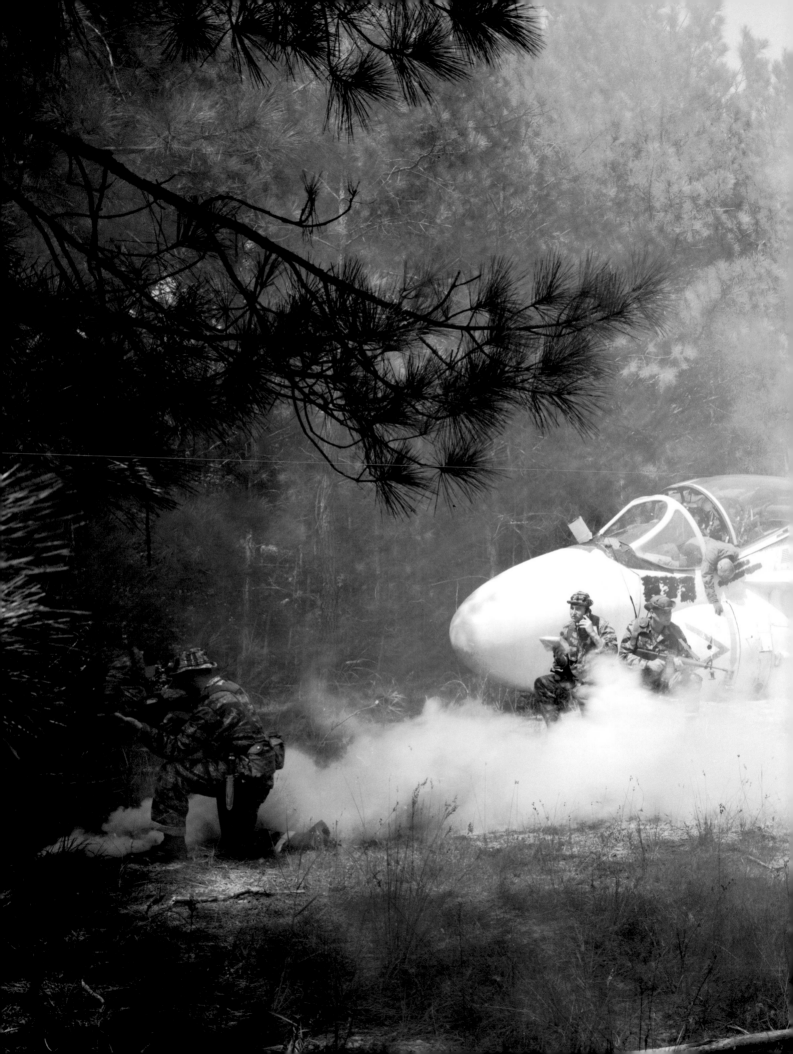

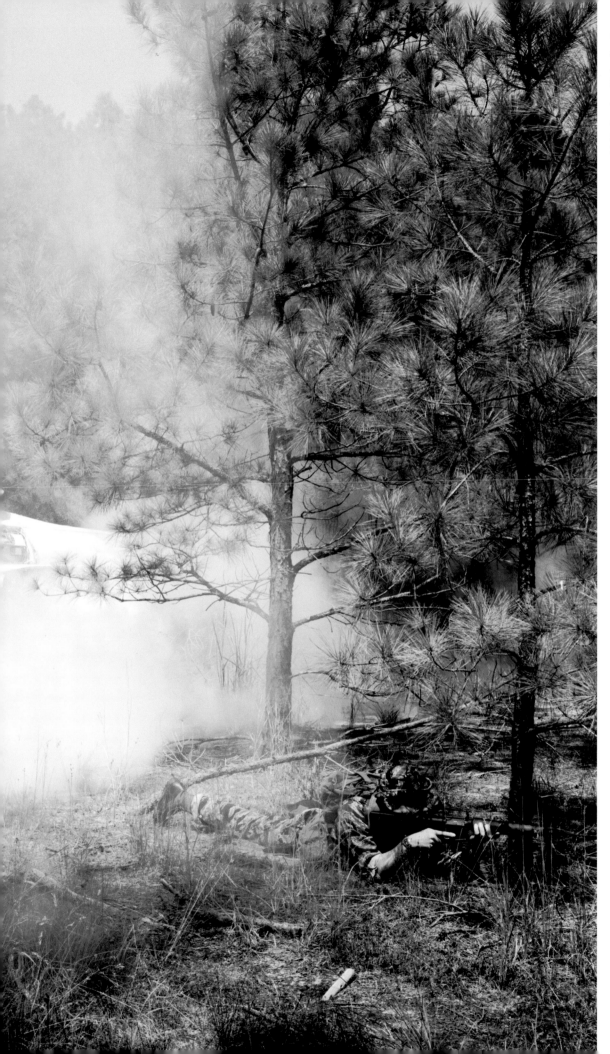

CAT. 7
AN-MY LÊ
Rescue (Small Wars), 1999–2002
Silver gelatin print
30 x 40 in.

Courtesy of the artist and
Murray Guy, New York, NY
Photo © An-My Lê

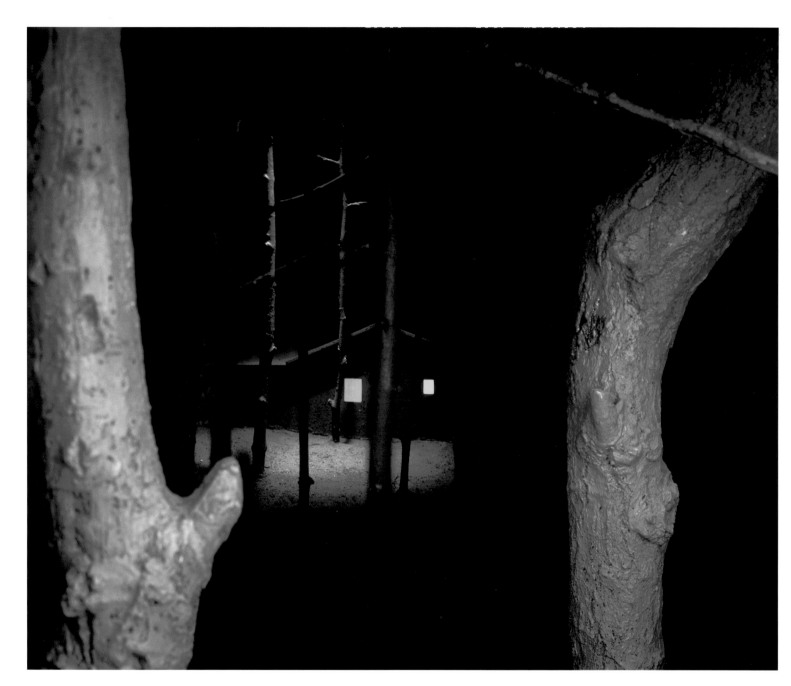

CAT. 9
JANET CARDIFF &
GEORGE BURES MILLER
Cabin Fever, 2004
Wood cabinet, mixed media
with binaural audio
81 1/2 x 47 x 75 1/2 in.

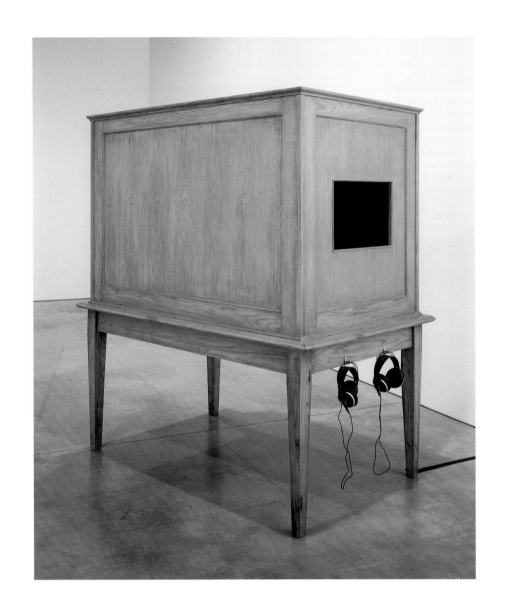

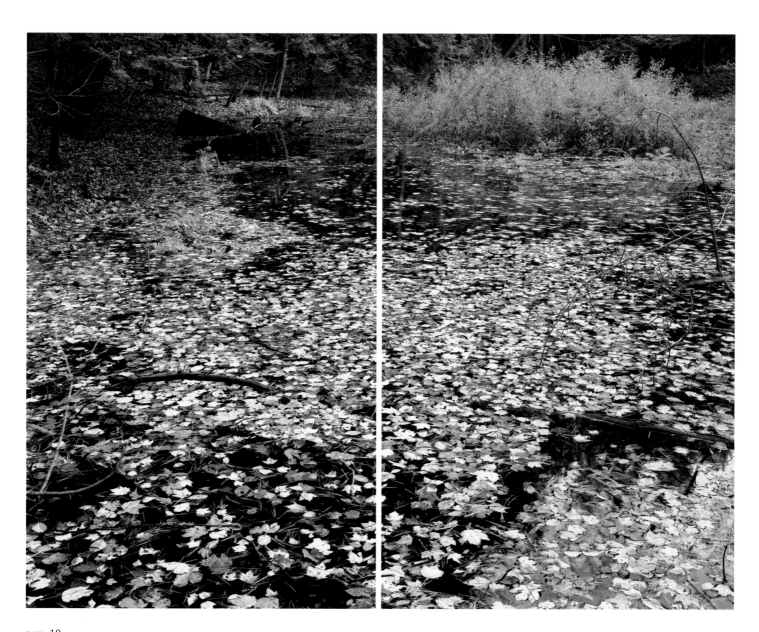

CAT. 10

JOSEPH BARTSCHERER
Pond (Forest Series), 1999–2000
4 C-prints face-mounted
to Plexiglas
96 x 240 in.

Courtesy of the artist and Marian
Goodman Gallery, New York, NY
Photo © Joseph Bartscherer

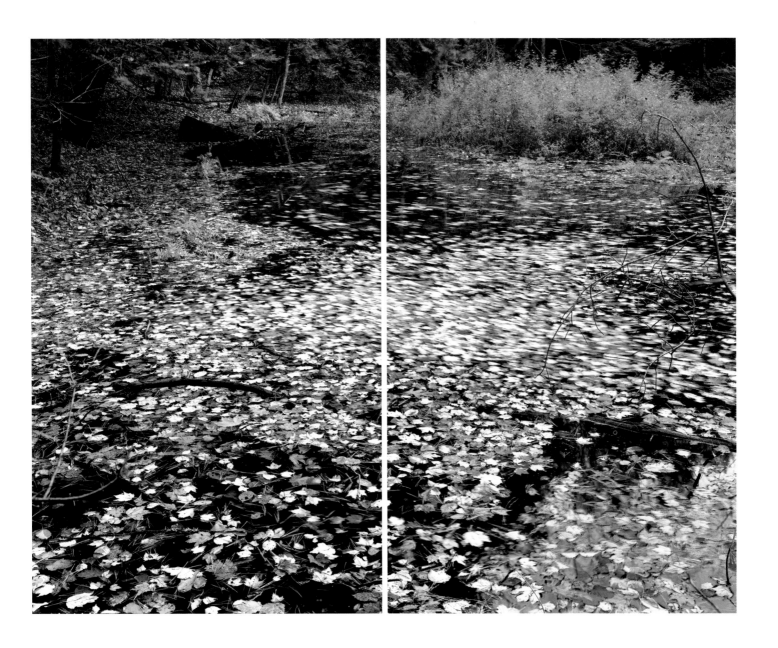

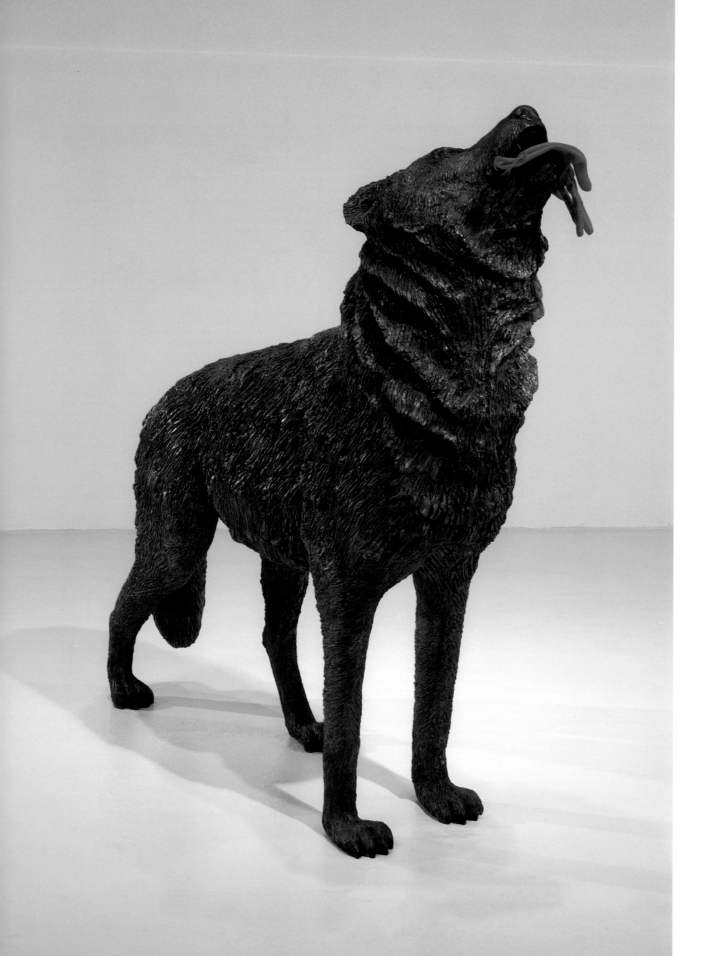

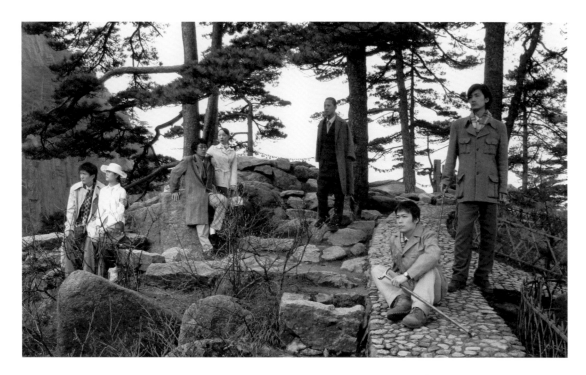

CAT. 12
YANG FUDONG
Seven Intellectuals in Bamboo Forest Part I, 2003
35 mm black & white film
transferred to DVD
29 minutes

Courtesy of the artist and
ShanghArt, Shanghai, China
Photo, film still © Yang Fudong

OPPOSITE
CAT. 11
KIKI SMITH
Wolf, 2001
Bronze and red cotton
44 1/4 x 46 x 12 in.

Courtesy of the artist and
PaceWildenstein, New York, NY
Lent by Boris Hirmas Said,
Coronado, CA
Photo © Kiki Smith

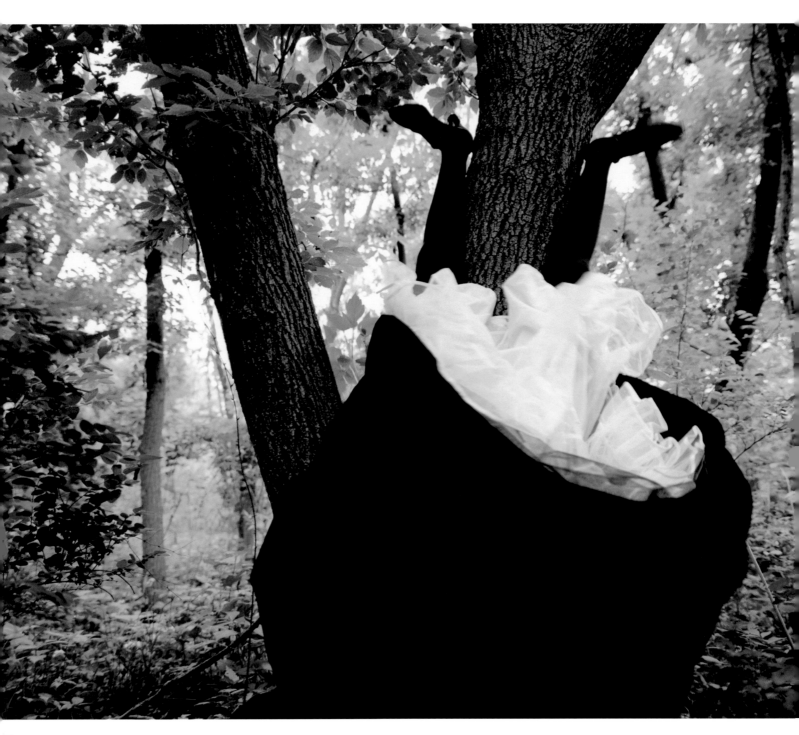

CAT. 13
ANNA GASKELL
Untitled #104, (A Short Story of
Happenstance), 2003
C-print
71 1/2 x 88 in.

Courtesy of the artist and Casey Kaplan
New York, NY
Lent by Heather and Anthony Podesta
Collection, Falls Church, VA
Photo © Anna Gaskell

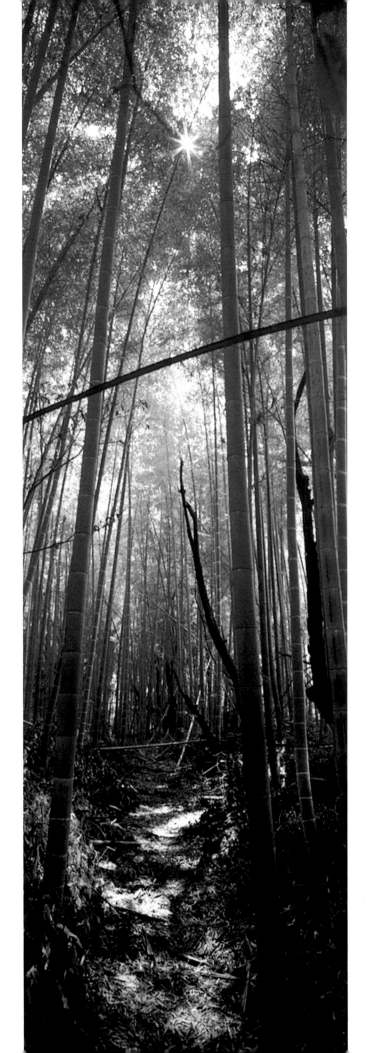

CAT. 14

WIM WENDERS

Bamboo Forest, Nara, Japan
2000
C-print
152 x 58 7/8 in.

Courtesy of the artist and
James Cohan Gallery, New York, NY
Photo © Wim Wenders

CAT. 15
ZWELETHU MTHETHWA
Untitled, 2004
C-print
61 x 78 in.

Courtesy of the artist and
Jack Shainman Gallery, New York, NY
Photo © Zwelethu Mthethwa

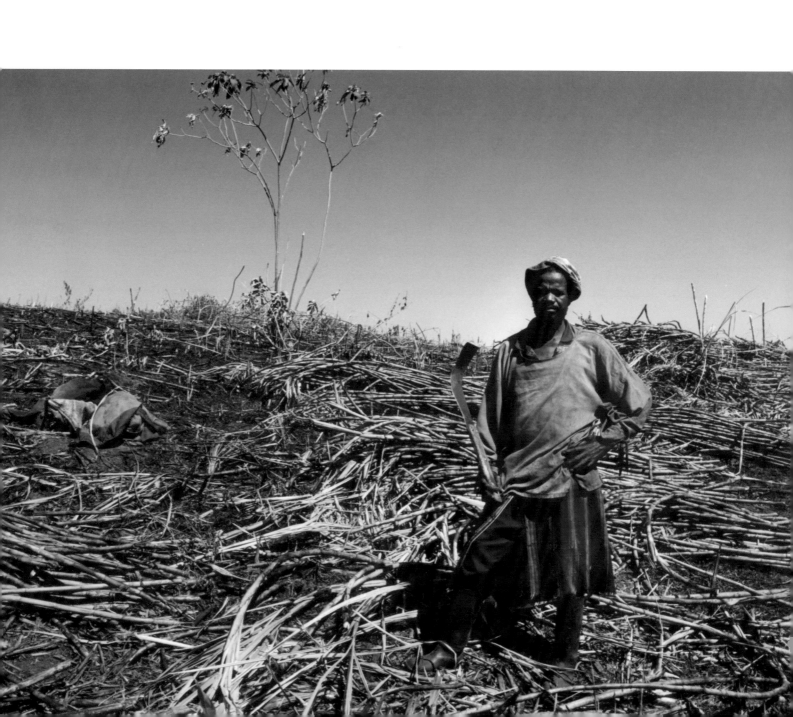

CAT. 16
RODNEY GRAHAM
Welsh Oaks #5, 1998
Monochrome color print
74 1/4 x 91 1/8 in.

Courtesy of the artist and
Donald Young Gallery, Chicago, IL
Lent by William and Ruth True,
Seattle, WA
Photo © Rodney Graham
Courtesy of Donald Young Gallery

CAT. 17
ALAN SONFIST
Time Landscape: Greenwich Village, 1965–1978
Documentary photographs
20 x 24 in. each

Courtesy of the artist and Paul Rodgers
9/W, New York, NY
Photo © Alan Sonfist

CAT. 18
ALAN SONFIST
Lost Falcon of Westphalia, 2004
Preparatory collage
10 x 20 in.

Courtesy of the artist and Paul Rodgers
9/W, New York, NY
Photo © Alan Sonfist

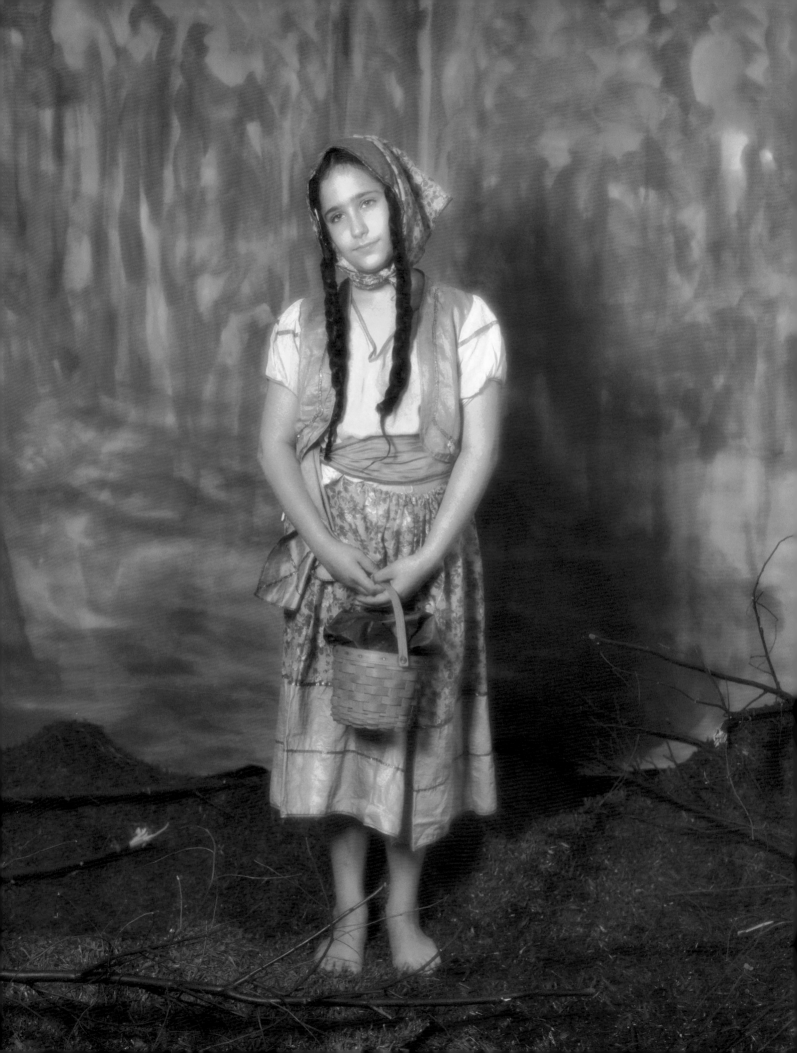

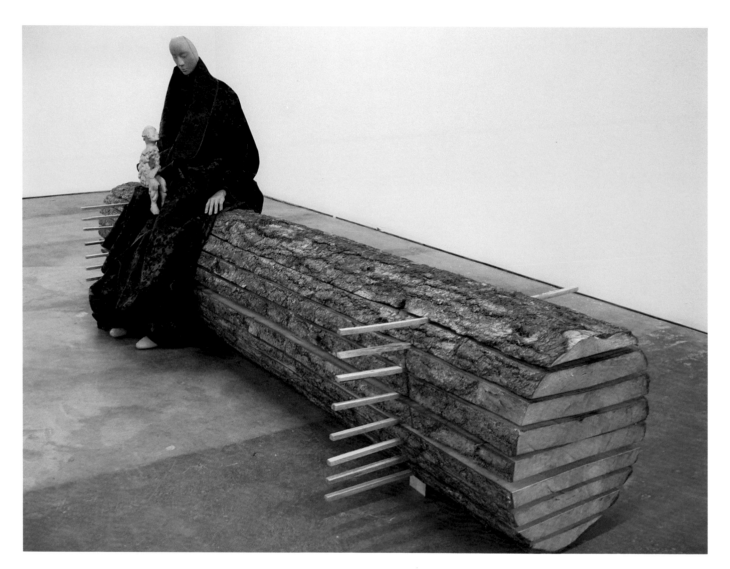

CAT. 21
PALOMA VARGA WEISZ
*Waldfrau Getarnt (Forest Woman
in Camouflage)*, 2002
Lime wood, larch, and camouflage
fabric
70 1/4 x 19 1/2 x 156 in.

Courtesy of the artist and
Barbara Gladstone Gallery, New York, NY
Lent by the Rubell Family Collection,
Miami, FL
Photo © Juan Valdez

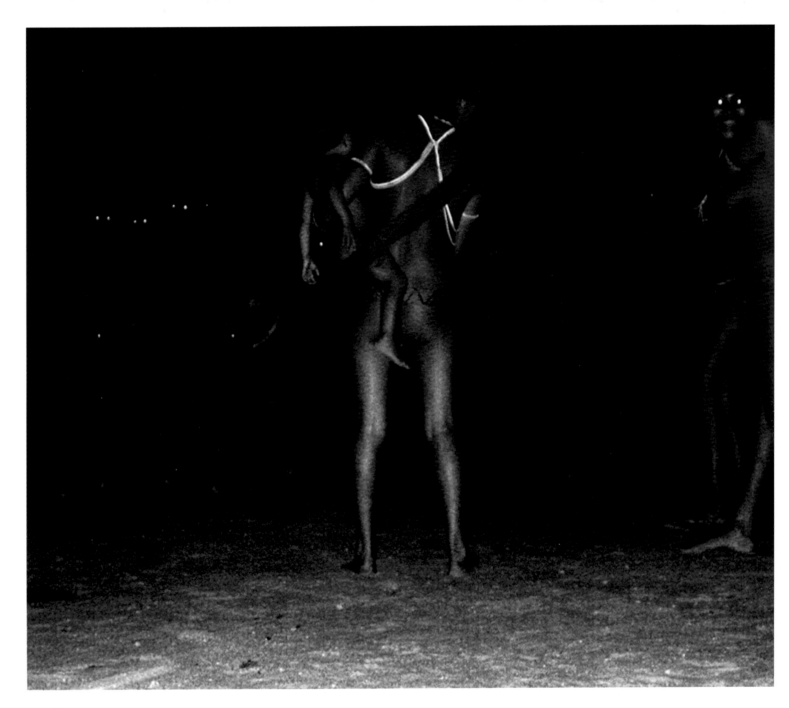

CAT. 22
STEPHEN VITIELLO
Photograph of Yanomami Villagers, 2003 (above, not exhibited)
Hea Binaural Recordings: Yanomami/Watoriki, 2003
5 sound works, stereo CD for headphone playback
Morning Rain
Davi and the Angry Parrott
Girl's Chorus
Morning Shaman
Long Walk
15 minutes

Commissioned by Fondation Cartier pour l'Art Contemporain, Paris,
for the exhibition *Yanomami: Spirit of the Forest.*

Courtesy of the artist, Fondation Cartier pour l'Art Contemporain,
Paris, France, and The Project, New York, NY and Los Angeles, CA
Photo © Stephen Vitiello

OPPOSITE
CAT. 23
RENÉE COX
Ambush: Maroon Series, 2004
Digital ink jet on watercolor paper
53 1/2 x 43 1/4 in.

Courtesy of the artist and
Robert Miller Gallery, New York, NY
Photo © Renée Cox

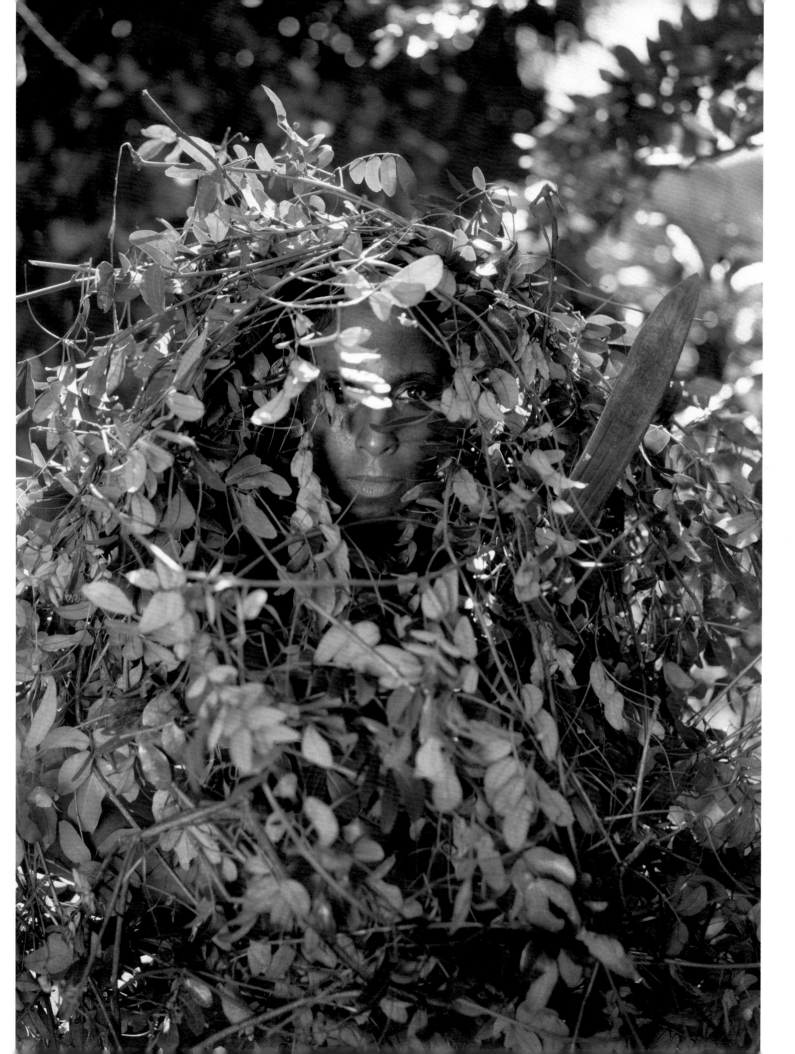

CAT. 24
ROSEMARY LAING
Groundspeed (Red Piazza #3), 2001
C-print
41 1/2 x 58 1/4 in.

Courtesy of the artist and
Galerie Lelong, New York, NY
Photo © Rosemary Laing

CAT. 25
HOPE SANDROW
Untitled Observations, July 29, 2004, Commencing,
Trout Pond Forest Preserve, South Hampton, NY,
2005
Color oil pigment print
96 x 24 in.

Courtesy of the artist, New York, NY
Photo © Hope Sandrow

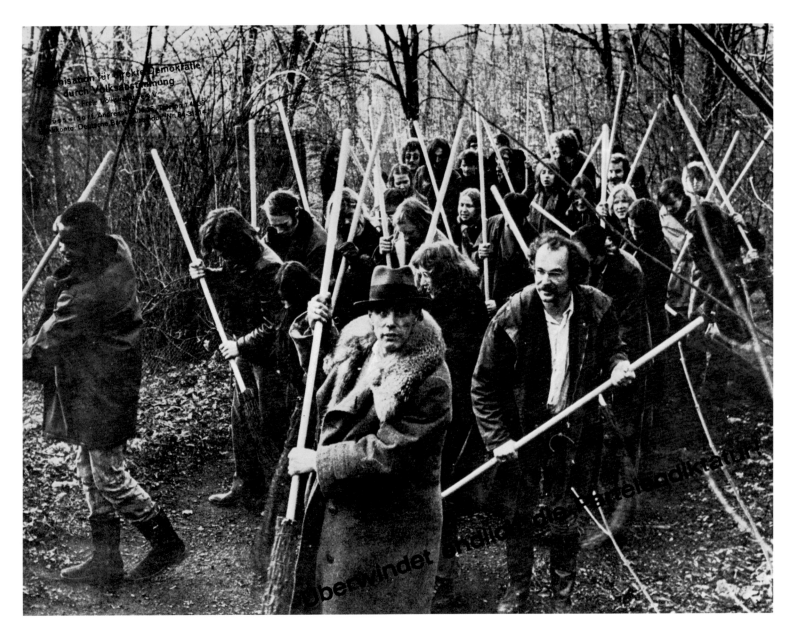

CAT. 26

JOSEPH BEUYS

Rettet den Wald (Save the Woods)
1972
Offset lithograph on paper
19 3/8 x 19 5/8 in.

Courtesy of Ronald Feldman
Fine Arts, New York, NY
Photo © D. James Dee
Courtesy of Ronald Feldman Fine Arts

JOAN JONAS
Waltz, 2004
DVD
6 minutes, 24 seconds

Courtesy of the artist, Yvon Lambert New York, and
New Museum of Contemporary Art, New York. NY
Photo, video stills © Joan Jonas

From *Point of View: An Anthology of the Moving Image* (boxed
set of eleven DVDs by the following artists: Francis Alÿs,
David Claerbout, Douglas Gordon, Gary Hill, Pierre
Huyghe, Joan Jonas, Isaac Julien, William Kentridge,
Paul McCarthy, Pipilotti Rist and Anri Sala. The edition
is unlimited.)

Produced by Bick Productions (Ilene Kurtz-Kretzschmar
and Caroline Bourgeois) and the New Museum of
Contemporary Art, New York (www.newmuseum.org).

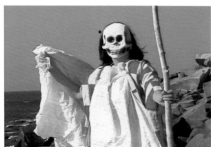

CAT. 28
WOLFGANG STAEHLE
Untitled, 2001 (not exhibited)
Live-feed projection
from the Internet.

Courtesy of the artist and
Postmasters, New York, NY
Photo © Wolfgang Staehle

CAT. 29
COLLIER SCHORR
Helmet: Kindling and Deer Feed, 2000
C-print
29 1/2 x 37 1/2 in.

Courtesy of the artist and 303 Gallery, New York, NY
Lent by Suzanne and Howard Feldman, New York, NY
Photo © Collier Schorr

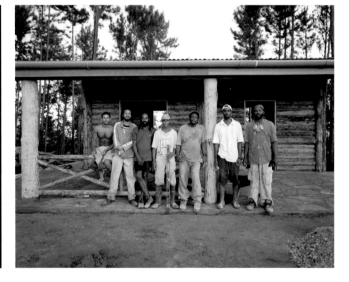

CAT. 30
SIMON STARLING
Trinidad House, 2003
10 C-prints
31 x 38 in. each

Courtesy of the artist and
Casey Kaplan, New York, NY
Lent by Martin Z. Margulies Collection,
Miami, FL
Photo © Simon Starling

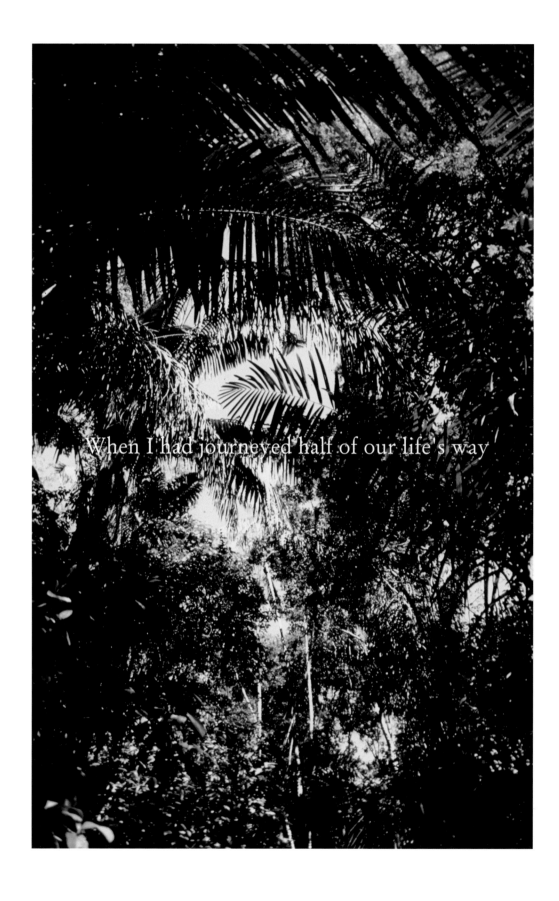

When I had journeyed half of our life's way

CAT. 31
SERGIO VEGA
Within Dante's Inferno, 1995–1996
9 C-prints mounted to Plexiglas
30 x 40 in. each

Courtesy of the artist, Gainesville, FL
Photo © Sergio Vega

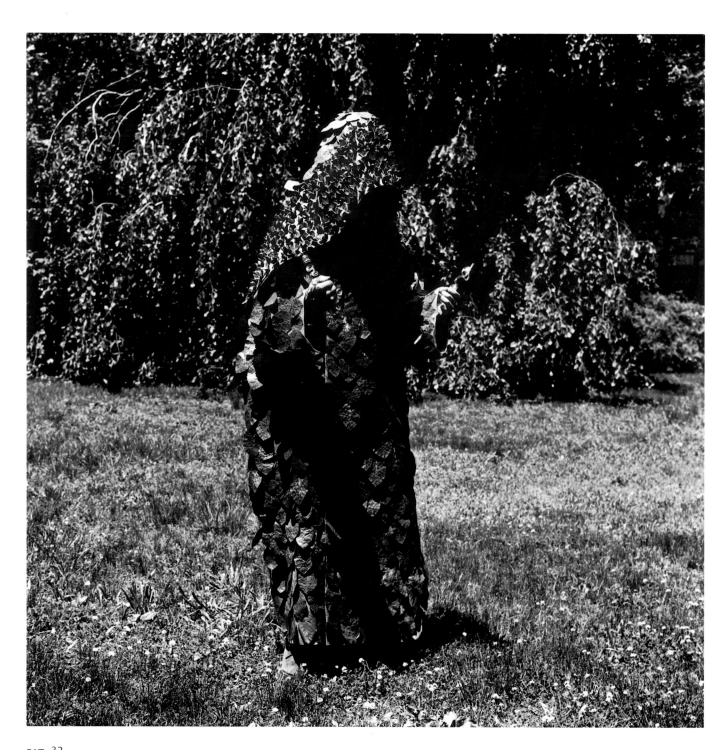

CAT. 32

PAUL ETIENNE LINCOLN
Passage to Purification, 2002
Silver print
8 x 10 in.
From a set of 24 photographs documenting
the performance *Distillate Still for Fagus Sylvatica*,
exhibited with other objects in vitrine

Courtesy of the artist and Alexander
and Bonin Gallery, New York, NY
Photo © Paul Etienne Lincoln

CAT. 33

DAVID CLAERBOUT
Le Moment, 2004
DVD
2 minutes, 44 seconds

Courtesy of the artist, Yvon Lambert New York, and
New Museum of Contemporary Art, New York, NY
Photo, video stills © David Claerbout

From *Point of View: An Anthology of the Moving Image* (boxed
set of eleven DVDs by the following artists: Francis Alÿs,
David Claerbout, Douglas Gordon, Gary Hill, Pierre
Huyghe, Joan Jonas, Isaac Julien, William Kentridge,
Paul McCarthy, Pipilotti Rist and Anri Sala. The edition
is unlimited.)

Produced by Bick Productions (Ilene Kurtz-Kretzschmar
and Caroline Bourgeois) and the New Museum of
Contemporary Art, New York (www.newmuseum.org).

JOSEPH BARTSCHERER
Pond, (Forest Series), 1999–2000
4 C-prints face-mounted to Plexiglas
96 x 240 in.
Courtesy of the artist and Marian
Goodman Gallery, New York, NY
Photo © Joseph Bartscherer
Cat. 10, pp. 42–43.

LOTHAR BAUMGARTEN
Der Ursprung der Nacht (Amazonas-Kosmos)
[*The Origin of the Night, (Cosmos of the Amazon)*], 1973–1978
Color film transferred to DVD
98 minutes
Courtesy of the artist and
Marian Goodman Gallery, New York, NY
Photo © Lothar Baumgarten
Cat. 2, p. 32.

JOSEPH BEUYS
Rettet den Wald (Save the Woods), 1972
Offset lithograph on paper
19 3/8 x 19 5/8 in.
Courtesy of Ronald Feldman
Fine Arts, New York, NY
Photo © D. James Dee,
Courtesy of Ronald Feldman Fine Arts, NY
Cat. 26, p. 58.

JENNIFER BOLANDE
Forest Spirits, 1997
6 Iris prints from a suite of 16
Watercolor ink on Arches paper
20 x 16 in. each
Courtesy of the artist and
Alexander and Bonin, New York, NY
Photo © Jennifer Bolande
Cat. 1, pp. 30–31.

JANET CARDIFF & GEORGE BURES MILLER
Cabin Fever, 2004
Wood cabinet, mixed media with binaural audio
81 1/2 x 47 x 75 1/2 in.
Courtesy of the artists and
Luhring Augustine Gallery, New York, NY
Photo © Janet Cardiff & George Bures Miller
Cat. 9, pp. 40–41.

DAVID CLAERBOUT
Le Moment, 2004
DVD
2 minutes, 44 seconds
Courtesy of the artist, Yvon Lambert New York, and
New Museum of Contemporary Art, New York, NY
Photo, video stills © David Claerbout
From *Point of View: An Anthology of the Moving Image.* (boxed
set of eleven DVDs by the following artists: Francis Alys,
David Claerbout, Douglas Gordon, Gary Hill, Pierre Huyghe,
Joan Jonas, Isaac Julien, William Kentridge, Paul McCarthy,
Pipilotti Rist and Anri Sala. The edition is unlimited.)
Produced by Bick Productions (Ilene Kurtz-Kretzschmar
and Caroline Bourgeois) and the New Museum of
Contemporary Art, New York (www.newmuseum.org).
Cat. 33, p. 67.

PETAH COYNE
Paris Blue, 2002–2003
Mixed media
51 x 132 x 58 in.
Courtesy of the artist and Galerie Lelong, New York, NY
Lent by the Joslyn Art Museum, Omaha, NE.
Purchased with funds provided by
Richard and Mary Holland.
Photo © Petah Coyne
Cat. 6, pp. 36–37.

RENÉE COX
Ambush: Maroon Series, 2004
Digital ink jet on watercolor paper
53 1/2 x 43 1/4 in.
Courtesy of the artist and
Robert Miller Gallery, New York, NY
Photo © Renée Cox
Cat. 23, pp. 54–55.

PATRICK DOUGHERTY
Holy Rope, 1992
Rinjyo-In Temple, Japan
Reeds and bamboo
Height 25 feet
Courtesy of the artist, Chapel Hill, NC
Photo © Patrick Dougherty
Cat. 5, p. 35.
* Included as an example of Dougherty's work.
 Photo and details of Nasher Museum project
 not yet available.

PHYLLIS GALEMBO
Little Red Riding Hood and Brown Bear, 1999
Cibachrome
30 x 40 in.
Courtesy of the artist and Sepia International,
New York, NY
Photo © Phylllis Galembo
Cat. 20, front cover.

PHYLLIS GALEMBO
Peasant Girl, 1999
Cibachrome
30 x 40 in.
Courtesy of the artist and Sepia International,
New York, NY
Photo © Phyllis Galembo
Cat. 19, p 52.

ANNA GASKELL
*Untitled #104, (A Short Story of
Happenstance)*, 2003
C-print
71 1/2 x 88 in.
Courtesy of the artist and
Casey Kaplan, New York, NY
Lent by Heather and Anthony Podesta Collection,
Falls Church, VA
Photo © Anna Gaskell
Cat. 13, p. 46.

RODNEY GRAHAM
Welsh Oaks #5, 1998
Monochrome color print
74 1/4 x 91 1/8 in.
Courtesy of the artist and
Donald Young Gallery, Chicago, IL
Lent by William and Ruth True, Seattle, WA
Photo © Rodney Graham
Courtesy of Donald Young Gallery
Cat. 16, p. 49.

CARSTEN HÖLLER
Loverfinch, 1995
DVD
13 minutes, 23 seconds
Courtesy of the artist and Casey Kaplan, New York, NY
Photo, video stills © Carsten Höller
Cat. 4, p. 34.

JOAN JONAS
Waltz, 2004
DVD
6 minutes, 24 seconds
Courtesy of the artist, Yvon Lambert New York, and
New Museum of Contemporary Art, New York, NY
Photo, video stills © Joan Jonas
From *Point of View: An Anthology of the Moving Image* (boxed
set of eleven DVDs by the following artists: Francis Alys,
David Claerbout, Douglas Gordon, Gary Hill, Pierre Huyghe,
Joan Jonas, Isaac Julien, William Kentridge, Paul McCarthy,
Pipilotti Rist and Anri Sala. The edition is unlimited.)
Produced by Bick Productions (Ilene Kurtz-Kretzschmar
and Caroline Bourgeois) and the New Museum of
Contemporary Art, New York (www.newmuseum.org).
Cat. 27, p. 59.

ROSEMARY LAING
Groundspeed (Red Piazza #3), 2001
C-print
41 1/2 x 58 1/4 in.
Courtesy of the artist and Galerie Lelong,
New York, NY
Photo © Rosemary Laing
Cat. 24, p. 56.

AN-MY LÊ
Ambush #2 (Small Wars), 1999–2002
Silver gelatin print
30 x 40 in.
Courtesy of the artist and
Murray Guy, New York, NY
Lent by Robert Hobbs and Jean Crutchfield,
Richmond, VA
Photo © An-My Lê
Cat. 8, back cover.

AN-MY LÊ
Rescue (Small Wars), 1999–2002
Silver gelatin print
30 x 40 in.
Courtesy of the artist and
Murray Guy, New York, NY
Photo © An-My Lê
Cat. 7, pp. 38–39.

PAUL ETIENNE LINCOLN
Distillate Still for Fagus Sylvatica, 2002
Objects used in performance *Distillate Still for Fagus Sylvatica*, and 24 silver prints entitled *Passage to Purification* documenting performance, in Plexiglas vitrine
33 1/2 x 24 x 22 1/2 in.
Courtesy of the artist and
Alexander and Bonin, New York, NY
Photo © Paul Etienne Lincoln
Cat. 32, p. 66.

IÑIGO MANGLANO-OVALLE
Oppenheimer, 2003
DVD video projection
3 minutes
Courtesy of the artist and
Max Protetch Gallery, New York, NY
Photo, video still © Iñigo Manglano-Ovalle
Cat. 3, p. 33.

ZWELETHU MTHETHWA
Untitled, 2004
C-print
61 x 78 in.
Courtesy of the artist and
Jack Shainman Gallery, New York, NY
Photo © Zwelethu Mthethwa
Cat. 15, p. 48.

HOPE SANDROW
Untitled Observations, July 29, 2004, Commencing, Trout Pond Forest Preserve, South Hampton, NY, 2005
Color oil pigment print
96 x 24 in.
Courtesy of the artist, New York, NY
Photo © Hope Sandrow
Cat. 25, p. 57.

COLLIER SCHORR
Helmet: Kindling and Deer Feed, 2000
C-print
29 1/2 x 37 1/2 in.
Courtesy of the artist and 303 Gallery, New York, NY
Lent by Suzanne and Howard Feldman, New York, NY
Photo © Collier Schorr
Cat. 29, p. 61.

COLLIER SCHORR
Matti: Back (There I Was…Ellwangen), 2001
C-print
44 x 35 in.
Courtesy of the artist and 303 Gallery, New York, NY
Photo © Collier Schorr
Not illustrated

KIKI SMITH
Wolf, 2001
Bronze and red cotton
44 1/4 x 46 x 12 in.
Courtesy of the artist and
PaceWildenstein, New York, NY
Lent by Boris Hirmas Said,
Coronado, CA
Photo © Kiki Smith
Cat. 11, p. 44.

ALAN SONFIST
Lost Falcon of Westphalia, 2004
Preparatory Collage
10 x 20 in.
Courtesy of the artist and Paul Rodgers/9W, New York, NY
Photo © Alan Sonfist
Cat. 18, p. 51.

ALAN SONFIST
Time Landscape: Greenwich Village, 1965–1978
Documentary photographs
20 x 24 in. each
Photo © Alan Sonfist
Courtesy of the artist and Paul Rodgers/9W, New York, NY
Cat. 17, pp. 50–51.

WOLFGANG STAEHLE
Untitled, 2001
Live-feed projection from the Internet.
Courtesy of the artist and Postmasters, New York, NY.
Photo © Wolfgang Staehle
Cat. 28, p. 60.
* Included as an example of Staehle's work. Photo and details of Nasher Museum project not yet available.

SIMON STARLING
Trinidad House, 2003
10 C-prints
31 x 38 in. each
Courtesy of the artist and
Casey Kaplan, New York, NY
Lent by Martin Z. Margulies Collection, Miami, FL
Photo © Simon Starling
Cat. 30, pp. 62–63.

SERGIO VEGA
Within Dante's Inferno, 1995–1996
9 C-prints mounted to Plexiglas
30 x 40 in. each
Courtesy of the artist, Gainesville, FL
Photo © Sergio Vega
Cat. 31, pp. 64–65.

STEPHEN VITIELLO
Hea Binaural Recordings: Yanomami/Watoriki, 2003
5 sound works, stereo CD for headphone playback
Morning Rain
Davi and the Angry Parrott
Girl's Chorus
Morning Shaman
Long Walk
15 minutes
Commissioned by Fondation Cartier pour l'Art Contemporain, Paris, France for the exhibition *Yanomami: Spirit of the Forest*.
Courtesy of the artist, Fondation Cartier pour l'Art Contemporain, Paris, France, and The Project, New York, NY and Los Angeles, CA
Photo © Stephen Vitiello
Cat. 22, p. 54.

PALOMA VARGA WEISZ
Waldfrau Getarnt (Forest Woman in Camouflage), 2002
Lime wood, larch, and camouflage fabric
70 1/4 x 19 1/2 x 156 in.
Courtesy of the artist and
Barbara Gladstone Gallery,
New York, NY
Lent by the Rubell Family Collection, Miami, FL
Photo © Juan Valdez
Cat. 21, p. 53.

WIM WENDERS
Bamboo Forest, Nara, Japan, 2000
C-print
152 x 58 7/8 in.
Courtesy of the artist and
James Cohan Gallery, New York, NY
Photo © Wim Wenders
Cat. 14, p. 47.

YANG FUDONG
Seven Intellectuals in Bamboo Forest Part I, 2003
35 mm black & white film transferred to DVD
29 minutes
Courtesy of the artist and ShanghArt, Shanghai, China
Photo, film still © Yang Fudong
Cat. 12, p. 45.